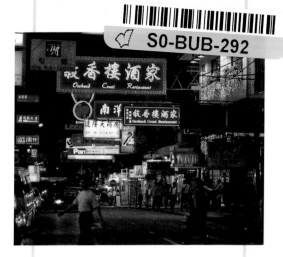

Essential
Hong Kong

by Tim Jepson

The clash of neon lights in the Wan Chai district

PASSPORT BOOKS
NTC/Contemporary Publishing Group

Colourful and charming traditional costume for Hong Kong's Bun Festival

Front cover: *statue of Buddha; Star Ferry; dragon dance; bird market*
Back cover: *mid-autumn festival*

Published by Passport Books, a division of NTC/Contemporary Publishing Group, Inc. 4255 West Touhy Avenue, Lincolnwood (Chicago), Illinois 60646-1975, U.S.A.

Copyright © The Automobile Association 1999
Maps © The Automobile Association 1999

Published by Passport Books in conjunction with The Automobile Association of Great Britain.

Written by Tim Jepson

Library of Congress Catalog Card Number: 98-68309
ISBN 0-8442-2204-6

Color separation: Pace Colour, Southampton

Printed and bound in Italy by Printer Trento srl

Contents

About this Book

Essential *Hong Kong* is divided into five sections to cover the most important aspects of your visit to Hong Kong.

Viewing Hong Kong pages 5–14
An introduction to Hong Kong by the author.
Hong Kong's Features
Essence of Hong Kong
The Shaping of Hong Kong
Peace and Quiet
Hong Kong's Famous

Top Ten pages 15–26
The author's choice of the Top Ten places to see in Hong Kong, in alphabetical order, each with practical information.

What to See pages 27–90
The three main areas of Hong Kong, each with its own brief introduction and an alphabetical listing of the main attractions.
Practical information
Snippets of 'Did you know…' information
4 suggested walks
2 features

Where To... pages 91–116
Detailed listings of the best places to eat, stay, shop, take the children and be entertained.

Practical Matters pages 117–24
A highly visual section containing essential travel information.

Maps
All map references are to the individual maps found in the What to See section of this guide.
For example, Hong Kong Park has the reference ➕ 29D3 – indicating the page on which the map is located and the grid square in which the Park is to be found. A list of the maps that have been used in this travel guide can be found in the index.

Prices
Where appropriate, an indication of the cost of an establishment is given by **£** signs:
£££ denotes higher prices, **££** denotes average prices, while **£** denotes lower charges.

Star Ratings
Most of the places described in this book have been given a separate rating:
❀❀❀ Do not miss
❀❀ Highly recommended
❀ Worth seeing

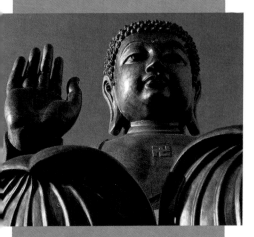

Viewing Hong Kong

Above: *statue of Buddha at the
Po Lon Monastery*
Right: *percussionist at Hong Kong's
Lion Dance Festival*

Tim Jepson's Hong Kong

Colour and drama at the annual Dragon Dance Festival

Hong Kong is more than a city: it is also some 236 islands, a mainland peninsula and vast swathes of beautiful countryside. What most people imagine as Hong Kong is Hong Kong Island, home to many of the key businesses, the best shops and hotels, and most of the skyscrapers that make up the city's fabled skyline. If you can arrange it, this is the place to try to stay.

If not, the chances are you will be in Kowloon, a peninsula of land across the harbour from Hong Kong Island, and equally – though less famously – a part of the city as its near neighbour. Wonderful old ferries and a modern metro system connect the two, so movement between the city's divided halves is easy. Kowloon also has more than its share of shops, sights and skyscrapers, not to mention spellbinding views of Hong Kong Island across the water.

For most people Kowloon and Hong Kong Island are all they want or need to see of Hong Kong. Both offer tantalising but entirely genuine glimpses of China, the Chinese and Chinese ways of life, albeit with the strange veneer and special qualities added by Hong Kong's recent British-dominated history. If you have time, however, try to visit one of the city's outlying islands, or parts of the New Territories – the land that stretches from Kowloon to the old Chinese border – not so much for the sights or scenery, but for an added insight into one of Asia's most complex and fascinating cities.

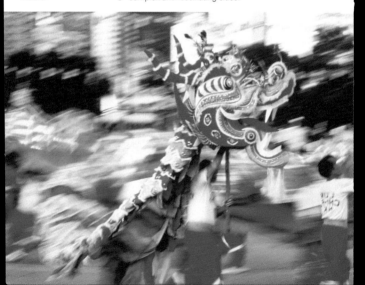

Hong Kong's Features

Hong Kong is the world's:
- Largest per capita consumer of oranges
- Third most competitive economy after Singapore and the USA
- Fifth-ranked banking and financial centre
- Leading importer of cognac brandy (600,000 litres in 1994)
- Eighth-largest trading entity after the Group of Eight (G8) nations
- Second-largest exporter of clothing (US$9.6 billion worth in 1995)
- Seventh-largest holder of foreign currency reserves
- Fifth-largest foreign exchange centre
- Third-largest gold bullion market
- First developing economy to achieve a top ten ranking (in 1991)
- Largest exporter of watches by volume
- Second highest per capita user of fax machines (270,000 lines)
- Largest per capita provider of public housing, accommodating 3.9 million people

Hong Kong has the world's:
- Second-largest film production industry (600 films in 1995)
- Longest film series (103) on martial arts hero Huang Fei-hong
- Largest cut emerald (86,136 carats)
- Highest life expectancy rates with Japan (79 years)
- Third-lowest infant mortality rates after Sweden and Japan (4.7 per 1,000)
- Highest per capita ownership of Rolls-Royce cars (1,500 cars or 1 per cent of all-time production)
- Second-highest Mercedes-Benz market share (30,000 cars or 11.6 per cent of the city's cars – a larger market share than Germany)
- Longest road and rail suspension bridge (Tsing Ma Bridge)
- Longest covered outdoor escalator (Ocean Park)
- Second-highest number of foreign consulates after the USA
- Eighth-largest stock exchange
- Tallest concrete-framed building (Central Plaza)
- Largest wall of glass (at the Convention and Exhibition Centre)
- Busiest McDonald's restaurants (25 of the world's busiest 50 outlets)
- Largest neon advertising sign (111.4m by 19m and over 13km of tubing)
- Largest container port and the first to handle over a million containers in a single month
- Most comprehensive optical fibre telecommunications network
- Highest ratio of land conserved in country parks (40 per cent)

Essential Facts and Figures
Hong Kong's total population is 6.3 million, of whom 98 per cent are of Chinese extraction. The population of Hong Kong Island is 1.3 million. The Hong Kong Special Administrative Region (SAR), equivalent to the area of the former colony, covers an area of 1,100sq km. Hong Kong Island covers an area of 78sq km; Kowloon covers just 46.6sq km. The distance from the southern tip of Hong Kong Island across the harbour and through Kowloon and the New Territories to the old Chinese border is just 40km.

Hong Kong has numerous country parks, but only a handful of central public gardens

Essence of Hong Kong

Hong Kong is a magical blend of East and West, of old and new, of materialism at its most rampant and the Orient at its most sublime. Its setting is one of Asia's most spellbinding, its skyline one of the world's most glittering. Dynamic and vibrant, it is a money-making city *par excellence*, the silvered ranks of skyscrapers monuments to trade and commerce, the bustle of its streets testimony to the fevered energy of its inhabitants. Yet it is also a city of calm and beauty, fringed with islands, chequered with oases of tranquillity and scattered with evocative reminders of centuries of history and tradition.

Below: *sweeping views of Hong Kong from Kowloon*
Inset: *dragon boat racing*

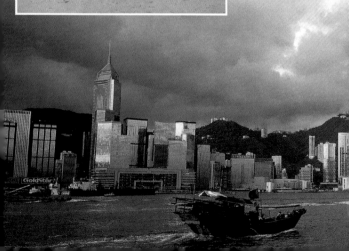

THE 10 ESSENTIALS

If you only have a short time to visit Hong Kong, or would like to get a really complete picture of the city, here are the essentials:

• **Visit the Peak** on the 1888 tramway and walk all or part of the Peak circuit for breathtaking views of the city and its surroundings (➤ 26 and 46).

• **Cross the harbour** on the Star Ferry between Kowloon and Hong Kong Island. Make the trip during the day and also at night to enjoy the city's illuminated skyline (➤ 24).

• **Ride an old-fashioned tram** all or part of the way between Kennedy Town and Causeway Bay for a perfect and straightforward sightseeing trip through the heart of the city.

• **Experience the sights,** sounds and powerful smells of a local street market (➤ 106).

• **Visit a traditional temple** such as Man Mo to see how the Chinese pay homage to their gods (➤ 18, 58, 60, 88).

• **Explore Bonham Strand** and Ko Shing Street, an area filled with shops and wholesalers devoted to traditional Chinese medicines (➤ 34).

• **Walk around the Hong Kong** Convention and Exhibition Centre and then take the lifts to the 45th floor of the nearby Central Plaza for superb views of the city and harbour (➤ 38, 51).

• **Visit the museums** of the Hong Kong Cultural Centre and then follow the nearby Waterfront Promenade for views across the harbour to Hong Kong Island (➤ 19, 79).

• **Take time out** in Hong Kong Park and visit its aviary, conservatory and Museum of Tea Ware (➤ 17, 56).

• **Visit the New Territories** or take a short ferry ride to Lamma, Cheung Chau, Lantau or another of the city's outlying islands to experience a different side of Hong Kong (➤ 85–6).

Putting the finishing touches to decorations for the Yuen Siu Festival

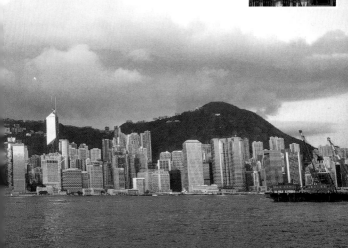

The Shaping of Hong Kong

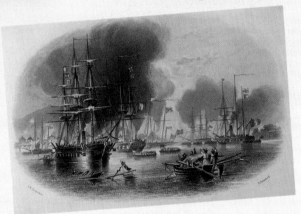

6000–4000 BC
Archaeological evidence suggests the existence of early fishing and farming communities in the Hong Kong region.

700 BC
Seafaring aboriginal tribes of Malay-Oceanic origin establish floating communities around Hong Kong.

221 BC
After unification of the Chinese Empire Hong Kong is ruled for a thousand years by magistrates answerable to a regional governor in Guangzhou (Canton).

AD 960–1500
Pirates roam the seas and islands around Hong Kong.

1514
Portuguese merchants establish a mainland trading base at Tuen Mun in the present-day New Territories.

1685
The Chinese allow Europeans limited trading rights in Canton, bartering tea, silk and other commodities in return for British- and French-imported silver.

1800
British traders import increasing quantities of opium: addiction grows in China and threatens the local economy.

1839
Lin Tse-Hsu, governor of Canton, orders the destruction of 20,000 chests of British-imported opium.

1840
Lord Palmerston dispatches an expedition-ary force to China after

British bombardment of Canton during the Opium Wars

skirmishes between British and Chinese forces (the First Opium War) and demands from British traders.

1841
After successes up and down the Chinese coast the force threatens Beijing (Peking) and pressures the Chinese into negotiations.

1841
While the Chinese stall, Captain Charles Elliot, commander of the British fleet, claims Hong Kong Island for the British on 26 January.

1842
After further British successes the Chinese cede Hong Kong Island to the British 'in

Britain occupies Hong Kong after the 1842 Treaty of Nanking

perpetuity' in the Treaty of Nanking.

1843
Hong Kong, named after *Heung Gong* (Fragrant Harbour), is formally declared a Crown Colony.

1850s
Traders such as William Jardine and James Matheson buy land and consolidate their position, laying the foundations for the colony's largest *hong* (trading company). The opium trade flourishes.

1860
Strained British–Chinese relations lead to the Second Opium War with the British again successful: the Convention of Peking cedes the British the tip of the mainland

Kowloon peninsula as far as Boundary Street.

1864
Hong Kong and Shanghai Bank is founded.

1888
A tramway is built to the Peak on Hong Kong Island.

1898
China's defeat by Japan leaves her weakened: Britain is able to demand more concessions. The Treaty of Peking cedes land north of Kowloon, later known as the 'New Territories', to the British on a 99-year lease.

1911
The collapse of China's Qing Dynasty sends a flood of Chinese refugees into Hong Kong.

1941
The Japanese attack Hong Kong on

8 December: 6,000 civilians and soldiers are killed. The British surrender on Christmas Day. The Japanese impose a brutal four-year regime.

1950s
The Communist victory in China sends many refugees to Hong Kong. US sanctions on China following the Korean War force the colony to diversify into new trading and business ventures.

1975
Refugee 'boat people' arrive from Vietnam at the rate of 600 a day: over 100,000 are accommodated.

1984
Although the 99-year lease applies only to the New Territories, the Sino-British Joint Declaration agrees on the return of the whole colony to China. China undertakes to preserve the region's capitalist system for at least 50 years.

1997
On 1 July Hong Kong is officially handed to the Chinese and becomes a Special Administrative Region (SAR) with some semi-autonomous powers. The British Governor is replaced by a Chief Executive.

Peace & Quiet

In the City

Few cities are as crowded and as bustling as Hong Kong, and finding a peaceful retreat from the people and the noise is far from easy. The most accessible oasis of relative calm is Hong Kong Park (➤ 17), closely followed by Kowloon Park in Tsim Sha Tsui (➤ 75). Quieter still are the heights of the Peak (➤ 26), where a few minutes' walk from the Peak Tower brings you to lovely wooded paths and plenty of sun-dappled corners (➤ 46). Boat trips to some of Hong Kong's many offshore islands also offer a marked contrast to the city, Lamma, Lantau and Cheung Chau being the most easily visited spots (➤ 85–6). Contact the Hong Kong Tourist Authority for further information on the islands and the areas outlined below.

Above: *Kowloon Park provides a retreat from the bustle of city streets*
Right: *calm and tranquillity in the form of Buddha*

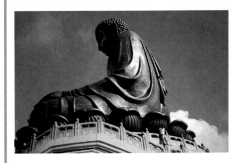

Deep Bay

Deep Bay, or Hau Hoi Wan, lies off the northwest corner of the New Territories. One of Hong Kong's finest – and most accessible – birdwatching areas, its broad mudflats provide feeding grounds for more than 40 types of bird, among them several rare and endangered species. Spring and autumn migration cycles are the best times to visit, the stretch of coast between Lau Fau Shan and Tsim Bei Tsui offering the best viewing possibilities. Rarities include the spoon-billed sandpiper and Normann's greenshank, while in winter you can expect to see cormorants, great crested grebes, red-breasted mergansers and the endangered Dalmatian pelican. The area is particularly known for its waders, especially whimbrels, curlews, black- and bar-tailed godwits, Kentish plovers and greater sand plovers.

Kam Shan

Kam Shan Country Park, one of many such parks in the New Territories, extends over 300 hectares of scrub, hills and semi-natural woodland. Although traversed by only one road, it is criss-crossed by a dense network of signed footpaths, among them part of the MacLehose Trail, a 100km track across the region. The most popular paths skirt the park's four reservoirs, patches of water which offer good birdwatching opportunities. Others meander through open woodlands of Chinese red pine and slash pine, where you may well catch a glimpse of long-tailed (or pig-tailed) macaques, a type of monkey first introduced into the region in 1920. Other small mammals include woodland shrews, while between October and November and April and May you should also see a host of exotic and colourful butterflies.

Sai Kung

Some of Hong Kong's loveliest scenery is to be found in the Sai Kung Country Park, a region situated in the eastern reaches of the New Territories. The construction of the High Island Reservoir locally has altered the area a little, but, to all intents and purposes, much of the countryside – grasslands, woodlands, plantations and open scrub – looks much as it must have done for centuries. Campsites and hostels provide accommodation if you wish to spend an extended period exploring the region, while paths provide access to most areas, allowing you to enjoy a profusion of plants and trees, insects, butterflies and birds. You may also come across snakes – most will slither away when disturbed – but steer clear of any you encounter: Hong Kong has at least eight highly venomous varieties, among them the King cobra and banded krait.

Escape the stresses of city life on one of Hong Kong's many offshore islands

Hong Kong's Famous

Jackie Chan

Actor Jackie Chan in action in the film Operation Condor

Jackie Chan seems to have been around for ever. Hong Kong's most popular and most famous film star has made over 100 films, a huge number in personal terms, but only a fraction of the 400 or more films made in the city every year. Renowned for his timing and death-defying stunts, Chan brings a light touch to his films, avoiding the typical macho world of the classic kung-fu movies in favour of self-deprecating humour. As well as an actor he is also a respected writer, director and producer. Although most of Chan's films are made in Cantonese, English sub-titles or dubbing allow many to be enjoyed by Western audiences.

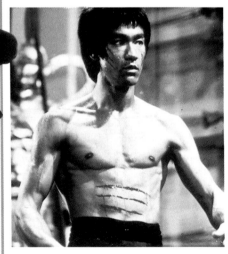

Right: *Bruce Lee – master of martial arts in a familiar action scene*

Gweilos

You won't have been in Hong Kong long before you hear the term *gweilo*, a Cantonese word which means 'ghost man' (*gweipor* is 'ghost woman'). It was originally coined by Hong Kong's Chinese population as a derogatory term for the ghostly pale white man. These days it is less of an insult, at least among *gweilos* themselves, and is now used, often with self-mocking humour, as a term for Hong Kong's white expatriate inhabitants, a group who form a tiny two per cent or less of the city's total population.

Bruce Lee

Jackie Chan is not Hong Kong's only famous kung-fu star. Although he was born in San Francisco, the fabled Bruce Lee (1940–73) spent much of his childhood in Hong Kong. Here, he learned his trade in the martial arts that were to lead to his legendary but short-lived film career. Many of his most famous movies were filmed in Hong Kong, and went on to become cult classics, and even more so after Lee's mysterious death at the age of 32. Among his best-known films are *Fist of Fury* and *Enter the Dragon*.

Top Ten

Above: *sleek lines of
Hong Kong Park Tower*
Right: *a bird show
at Ocean Park*

1
Aberdeen

Enjoy a ride in an old-fashioned junk or sampan around the bustling harbour at Aberdeen, famed for its vast floating restaurants and its temples.

Aberdeen lies tucked away on the southern reaches of Hong Kong Island. Two centuries ago it was a refuge for pirates. Later it became a centre for incense production. Later still its name – Heung Gong, or Fragrant Harbour – was anglicised and applied to the whole city. More recently it was a simple fishing village. Today Aberdeen is a modern town, with streets full of high-rise buildings, and its vibrant waterfront home to the yachts of Hong Kong's rich and famous.

Traditional and often impoverished ways of life still prevail, however, none more striking than the harbour's hundreds of junks and sampans, old-fashioned boats which provide floating homes for thousands of people. Taking a ride on one of the boats is a popular activity – you will inevitably be approached by people trying to sell you a trip – but try to stick with licensed operators. Alternatively take a shuttle boat to one of the harbour's famous 'floating restaurants', vast and gaudily decorated affairs aimed unashamedly at tourists, but fun nevertheless.

Other things to see include the traditional boatyards of Ap Lei Chau across the harbour (access by boat or bridge) and the Tin Hau Temple (1851), the latter dedicated to the Queen of Heaven (or Goddess of the Sea), protector of seafarers. A statue of the goddess stands inside the temple flanked by two generals: one who can hear clearly and another who can see clearly. Hung Hsing, another small temple at the southern end of the main street, is also worth visiting.

81D2

Tin Hau Temple: corner of Tsung Main Street and Aberdeen Reservoir Road. Hung Hsing Shrine: Old Main Street

Floating restaurants (► 93) plus other bars and restaurants (£–£££)

7 from Central Bus Station, 70 from Exchange Square terminal, 72 from Moreton Terrace in Causeway Bay

Few

Sampan rides: moderate

Ocean Park (► 20), Repulse Bay (► 58), Stanley (► 23)

Licensed sampan boats operate from the main seawall opposite the Aberdeen Centre

An old-fashioned ferry passes one of Aberdeen's famous floating restaurants

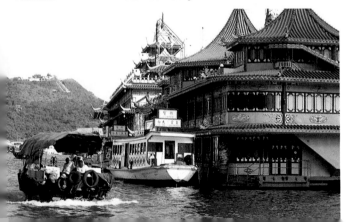

2
Hong Kong Park

Hong Kong's delightful park has survived the developers to provide a beautiful retreat from the hustle and high-rises of the city centre.

Shopping and high-rise modern architecture can only hold your attention for so long, which makes Hong Kong's principal park a welcome and rather unexpected relief from the city's many urban distractions. Spread over 10ha, the park opened in 1991 on the site of the old Victoria Barracks, and in its layout deliberately avoided a strictly naturalistic appearance in favour of a partially artificial approach to landscaping (much of the area's original vegetation had long-since vanished in any case). Skilful design work has artfully folded the park into the contours of the surrounding hillside, dramatically juxtaposing the ranks of skyscrapers on one side with almost open hilly slopes on the other.

 29D3

✉ Entrances on Cotton Tree Drive and Supreme Court Road, Central, Hong Kong Island

🕐 Park: daily 6:30 or 7AM–11PM. Aviary: daily 9–5

🍴 Café and bar (£)

Ⓜ Admiralty

♿ Good (some steep paths and steps)

✋ Free

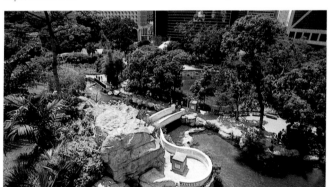

Among the park's many features are lakes, artificial waterfalls, numerous plants (look out for the giant bamboo in particular), a visual arts centre, children's playground, restaurant, viewing tower, *tai chi* garden and the outstanding Museum of Tea Ware in Flagstaff House at the park's northern tip (► 56). Museum aside, the park's highlights are its many peaceful corners, a large aviary and a modern conservatory, the last – the largest in Southeast Asia – home to 200 plant species divided into tropical and semi-arid varieties. The still more impressive aviary replicates a tropical rainforest habitat, tree-high walkways bringing you into close contact with some 150 species of (and 500 individual) exotic and brightly coloured birds as you drop down through the complex.

 Museum of Tea Ware (► 56), Zoological and Botanical Gardens (► 69)

Hong Kong Park, an oasis of green amidst the city's downtown skyscrapers

3
Man Mo Temple

28B4

126 Hollywood Road (at the Ladder Street junction), Sheung Wan, Hong Kong Island

Daily 7–5

Near by (£)

Sheung Wan

Poor

Free but donations welcomed

Bonham Strand (► 34), Hollywood Road (► 49), Hong Kong Museum of Medical Sciences (► 52)

Visitors are welcome in the temple and need not feel intimidated, but should show due consideration to worshippers

Coils of incense in the Man Mo Temple are lit as an offering to the gods

Man Mo Temple, with its dark, atmospheric interior, provides a wonderful contrast to the modern cut and thrust of the city centre.

Hong Kong's oldest and most famous temple (*c*1847) is dedicated to two gods, one civilian, the other military: Man, or Man Cheong, the god of literature, and Mo, or Kuan Ti, the god of war. Figures of each stand on the main altar, Man dressed in green holding a writing brush and Mo arrayed in red brandishing a sword. Man (literally 'civil') was a 3rd-century BC Chinese statesman, Mo ('military'), a 2nd-century AD Chinese soldier. Man is the traditional protector of civil servants, Mo – worshipped by Taoists and Buddhists alike – the guardian of armies, policemen, secret societies and pawnbrokers. Lesser gods lie ranged beside the temple's altar statues, notably Pao Wong, the god of justice, and Shing Wong, a god who keeps watch over the surrounding district.

A visit here is a must if you want to savour the flavour of a Taoist temple (albeit one with Buddhist overtones), the atmosphere mystical but oddly casual, the dusky air pungent with the scent of incense burning from huge coils hung from the roof. A bell and drum by the entrance sound when a prayer or offering is made – usually fruit or sticks of incense. The large bell, cast in Guangzhou (Canton), dates from 1846, its smaller neighbour, on the left, from 1897. Also look out for the two antique sedans under glass by the altar, originally used to carry the statues of Man and Mo during ceremonial processions.

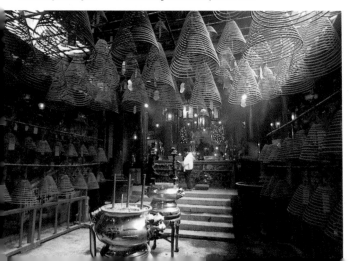

4
Museum of Art

Hong Kong's cultural museum contains a superb collection of Chinese art and artefacts in a magnificently designed modern setting.

The Hong Kong Museum of Art opened in 1989 as part of the city's superb new Cultural Centre. Ranged over five floors, it is divided into six separate galleries, the majority of which are devoted to Chinese art and artefacts from the past. Room is also found, however, for a range of contemporary and Western art, as well as for a variety of temporary exhibitions.

 70B1

 10 Salisbury Road, Tsim Sha Tsui, Kowloon

2734 2167

Mon–Wed, Fri, Sat 10–6, Sun 1–6. Closed Thu, some public holidays

Café within Cultural Centre (£)

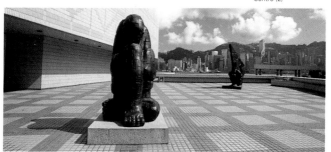

Among the art galleries the undoubted highlight is the third floor's Historical Pictures Collection, home to more than a thousand paintings, drawings and prints devoted almost entirely to topographical scenes of Hong Kong and its immediate surroundings. Among them is the first known painting of Hong Kong, an Aberdeen waterfall scene executed by William Havell in 1816. This and other paintings provide a fascinating documentary narrative of Hong Kong over the decades, from the days when it amounted to little more than sandy beaches and a handful of waterfront buildings.

Elsewhere, be certain to some spend time in the gallery devoted to Chinese antiquities, a collection containing over 3,000 wide-ranging artefacts. Of particular interest are two Tang Dynasty tomb guardians (AD 618–906), pot-bellied figures in the form of mythical beasts. Also look out for the almost translucent rhino-horn cups, prized for their reputed ability to advertise the presence of poison.

Other exhibits trace the development of porcelain and crafts such as bamboo carving, lacquer work and metal casting, while the Decorative Arts section contains, among other things, mouthwatering displays of jade, ivory, glassware and Ming Dynasty ceramics.

Tsim Sha Tsui

All services to Tsim Sha Tsui bus terminal

Star Ferry Pier

Inexpensive

Hong Kong Cultural Centre (➤ 72), Hong Kong Space Museum (➤ 22), Peninsula Hotel (➤ 77), Star Ferry (➤ 24)

Above: *modern sculptures adorn the panoramic promenades outside the Hong Kong Museum of Art*

19

5
Ocean Park

+ 81D2

✉ Wong Chuk Hang Road, Hong Kong Island

☎ 2552 0291

🕐 Ocean Park: daily 10–6. Water World: daily Jun–Oct 10–6; Jul–Aug 9–9

🍴 Several fast-food outlets (£)

🚌 A special Ocean Park Citybus leaves half-hourly from Admiralty MTR station; minibus 6 from Star Ferry terminal (daily except Sun)

♿ Excellent

✋ Ocean Park: expensive (ticket includes all rides and shows). Water World: expensive

↔ Aberdeen (► 16), Repulse Bay (► 58), Stanley (► 23)

❓ Allow a full day: arrive early and try to avoid weekends; also consider bringing a picnic

The dazzling Shark Aquarium at Ocean Park

Ocean Park is Southeast Asia's largest entertainment centre, offering a wide range of family-oriented activities.

Since its opening in 1977, Ocean Park has mushroomed into a vast complex of attractions overlooking the sea on the southern side of Hong Kong Island. Foremost among these are an amusement park, oceanarium and open-air theme park, an ensemble which together attracts well over three million visitors a year. It's a great place to visit with children, offering enough to keep you occupied for at least a day. It's also busy, however, especially in summer and at weekends and public holidays, when the chances are you will have to wait in line for the most popular rides.

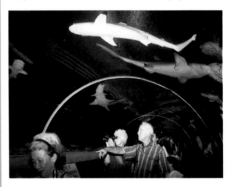

You start at Lowland, offering many attractions, including parks, gardens, a butterfly house and an adventure playground. From here an exhilarating cable-car ride takes you over the sea to the Headland section, where you'll find many of the amusement park rides (notably the electrifying Crazy Galleon and 80kph Dragon roller-coaster), the Ocean Theatre (home to performing dolphins, killer whales and high divers), a large aquarium, a seal and penguin sanctuary, and the 72m Ocean Park Tower (which offers superb views of the coast). From here you ride down the world's longest outdoor escalator to the Middle Kingdom, a theme park which employs arts, crafts, live theatre, opera performances and other displays designed to provide a 'living history of Chinese culture'.

Adjacent to Ocean Park and under the same management lies the equally popular Water World, a fabulous collection of giant water slides, chutes, swimming pools and other watery attractions.

6
Science Museum

This state-of-the-art museum provides a perfect accompaniment to the Space Museum, offering a wide range of interactive and other displays.

Hong Kong Science Museum is situated in a suitably futuristic-looking building on the eastern fringes of the Tsim Sha Tsui district, and has managed in a short time – despite its slightly outlying location – to become one of the city's most popular sights. Children are likely to find it especially appealing. You could happily spend several hours exploring its three floors, either casting your eye over the 500 major exhibits or getting to grips with some of the many interactive and audio-visual displays. It's well worth avoiding some of the busier periods – mid-morning and most of Sunday – when you may have to wait in line for some of the more popular exhibits.

Almost anything with an even vaguely scientific bent qualifies for attention. The workings of the most basic everyday appliances are explained – items from your kitchen or bathroom, for example – as are the intricacies of more advanced disciplines such as robotics and computer science. Special attention is paid to branches of technology beloved of Hongkongers, notably cellular phones and fax machines: the city has the world's highest per capita number of cellular phones and pagers – 680,000 in 1995, or one for every five people – and the world's second highest rate of fax penetration (over 270,000 dedicated lines). Scientific history is not forgotten, however, and the museum's exhibits include a miniature submarine, several early computers and the DC3 aeroplane that launched the now famous Cathay Pacific airline.

➕ 70C3

✉ 2 Science Museum Road (near the junction of Chatham Road South and Granville Road), Tsim Sha Tsui East, Kowloon

☎ 2732 3232

🕐 Tue–Fri 1–9, Sat, Sun, some public holidays 10–9. Closed Mon, some public holidays

🍴 Café (£)

🚇 Jordan or Tsim Sha Tsui

🚌 Green minibus 1

♿ Excellent

✋ Moderate

↔ Hong Kong Cultural Centre (► 72), Hong Kong Museum of Art (► 19), Hong Kong Space Museum (► 22), Nathan Road (► 76), Star Ferry (► 24), Waterfront Promenade (► 79)

A mass of shining steel in the Science Museum

7
Space Museum

70B1

10 Salisbury Road, Tsim Sha Tsui, Kowloon

2734 2722

Tue–Fri 1–9, Sat, Sun, public holidays 10–9. Closed Mon. Space Theatre shows from 2:30, earlier on Sat, Sun

Cultural Centre (£)

Tsim Sha Tsui

Tsim Sha Tsui

Star Ferry Pier

Excellent

Moderate

Hong Kong Museum of Art (► 19), Hong Kong Science Museum (► 21),

Children under six not admitted to the Space Theatre

The distinctive outlines of the Space Museum and Hong Kong Cultural Museum

The Space Museum, home to one of Asia's most sophisticated planetariums, will appeal to anyone with an interest in space, science and technology.

Hong Kong Space Museum opened in 1980 and was an immediate success, especially among children, thanks largely to its fascinating exhibits and the wide range of its mainly hands-on displays. It has three principal sections: the Hall of Astronomy, the Hall of Space Science and the combined Planetarium and Omnimax Theatre (the Space Theatre). Most people are tempted by the last, and in particular by the Omnimax Theatre, where special-format films – mostly on space, sport and the natural world – are shown on a huge screen. The Theatre has around seven shows daily (except Tuesday), including some in Cantonese, for which headphone translations are available.

Elsewhere, the exhibits of the Space Science hall include pieces of moon rock, a mock-up of the Space Shuttle and the original Mercury space capsule used by astronaut Scott Carpenter in 1962. A variety of video, push-button and advanced audio-visual displays provides plenty of absorbing and educational titbits, with a particular emphasis on Chinese contributions to astronomy across the centuries.

Among other things you learn that it was the Chinese who first recorded Halley's Comet, were the first to use gunpowder (and thus lay the foundations of rocket science) and the first to map the movement of the heavens. Other exhibits concentrate on solar science, providing background to phenomena such as sun spots and solar eclipses. There's also the chance to look through a telescope specially adapted for looking at the sun.

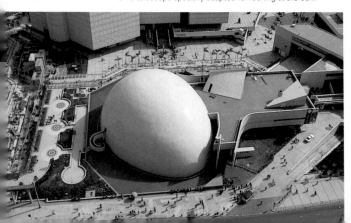

8
Stanley

The village of Stanley is a popular excursion from downtown Hong Kong, thanks to its bars, beaches and the various stalls of its vibrant market.

Superb beaches are just one reason to visit the outlying village of Stanley

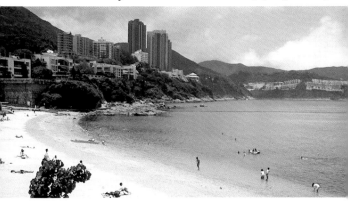

Visitors who take no other excursion in Hong Kong often make the effort to see Stanley, a coastal village on the southern side of Hong Kong Island. Most are drawn as much by the scenery *en route* and the reputation of its famous market as by any preponderance of attractions to visit or activities to do once they get there.

One of the island's oldest communities, Chek Chue (Robber's Lair), as it was then known, already had a population of around 2,000 when the British arrived in 1841. Later it became an important British military garrison, becoming involved in bitter fighting during the Japanese invasion in 1941. The poignant and beautifully kept Military Cemetery, a short walk north of the village, is well worth a visit.

Most people come here for the market, however, located just up the road from the harbour. Over the years it's become known for its bargain clothes, though these days prices are not as keen as they were. It's still fun to browse, however, and the stalls are as good a place as anywhere in Hong Kong to buy souvenir T-shirts or inexpensive Chinese artefacts and household goods. After seeing the market wander down to Stanley's waterfront Main Street, lined with bars, pubs and restaurants popular with ex-pats. At its western end stands the Tin Hau Temple (1767), one of the oldest in Hong Kong. Around a kilometre to the south lies St Stephen's Beach, which is nicer than the more convenient Stanley Main Beach.

✚ 81D2

✉ Market: Stanley Market Road. Tin Hau Temple: Stanley Main Road. St Stephen's Beach and Stanley Military Cemetery: Wong Ma Kok Road

🕐 Market: daily 10–7. Tin Hau Temple: usually daily 7–5

🍴 Restaurants (££–£££), bars and cafés (£)

🚌 6, 6A and 6X from Exchange Square; 260 from the same terminal goes via a less scenic route; 63 from Tung Lo Wan Road, Causeway Bay

♿ Few: the market is crowded and has narrow aisles

↔ Aberdeen (► 16), Ocean Park (► 20), Repulse Bay (► 58)

9
Star Ferry

*A ride on the Star Ferry provides the best possible
introduction to Hong Kong, offering magnificent
vistas of the city's harbour and famous skyline.*

The Star Ferry has linked Hong Kong Island and Kowloon
since 1898. For just a couple of dollars you are treated to
one of the world's most spectacular ferry rides, the robust
little green and white boats dodging the intense water-
borne traffic on what was once the world's finest and
busiest deep-water anchorage.

Strictly speaking there are several Star Ferries, each
plying slightly different routes across the harbour. The
route everybody rides, however, is the one between the
piers on Kowloon close to the Cultural Centre and the
heart of the Central district on Hong Kong Island. The trip
takes around seven minutes, and you can choose between
upper and lower decks, the upper deck costing a few
cents more. You enter the quay via coin-operated
turnstiles, so be sure to have some change, and then wait
with the chaotic-looking crowds for the next boat (queue at
a ticket office by the turnstiles if you have no change). If
boats are full – and numbers are monitored – simply wait a
few minutes for the next ferry.

Once underway it's difficult to know where to look.
Behind and in front of you skyscrapers rise from the water-
front, combining with the hills behind to produce one of

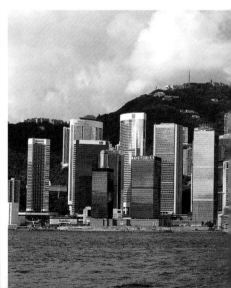

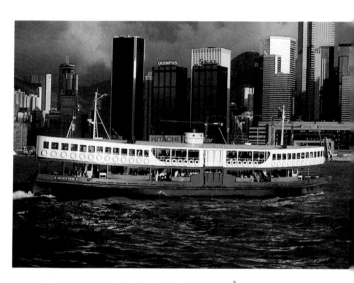

the world's most spectacular city skylines. Below and all around you the water is alive with countless boats, while on board the massed ranks of passengers provide a people-watching spectacle in their own right.

The Star Ferry has plied the harbour for over a century offering superb views of the city's skyline

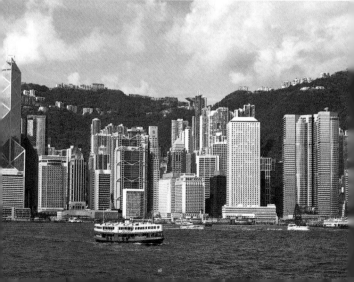

10
The Peak

28A2

Peak Tower: Peak Road.
Lower Peak Tram
Terminal: Garden Road

Peak tram: daily,
7AM–midnight

Peak Tower and Galleria
(£–£££)

Free shuttle from
Edinburgh Place at City
Hall: daily 10–8; bus 15
from Exchange Square

Tram: poor. Peak
Tower: excellent

Peak Tram: moderate.
Peak Tower observation
deck: free

Hong Kong Park
(➤ 17), St John's
Cathedral (➤ 59),
Zoological and Botanical
Gardens (➤ 69)

Arrive as early as
possible at the Tram
Terminal to avoid long
queues for the tram

*Views from the Peak
are breathtaking by day
or night*

*Hong Kong has two essential sights: the Star Ferry
and the Peak, both of which provide unforgettable
panoramas of the city's fabled skyline.*

Few cityscapes are as spellbinding as the view of Hong
Kong from the Peak (552m), the green-swathed mountain
that looms above Central's tight-packed ranks of
skyscrapers. Cool, clear and removed from the city's
bustle, the area has long been one of the city's most
exclusive retreats: the former British Governor had a
summer residence here (damaged during the Japanese
occupation) while the handful of grand houses scattered
across the slopes are by far the city's most coveted.

A path was cleared to the summit as early as 1859 – a
sedan chair was then the preferred mode of transport –
while road access was secured in 1924. Most people
today ride up on the famous Peak Tram, built in 1888, an
impossibly steep but wonderful way to reach the Peak
Tower, a small complex of shops, cafés and other minor
attractions at the tram's upper terminal. Sit on the right of
the tram for the best views, and be certain to wait for
a clear day to make the trip. Do not leave the Tower
complex – which is a little disorienting – without riding
the escalators to the outdoor observation deck: the views
are breathtaking.

Across the road from the Tower lies the Peak Galleria,
another mall complex, though your time will be better
spent walking all or part way around the Peak (➤ 46). The
full walk takes around an hour, but is easy and straight-
forward, and the views, not to mention the lovely wooded
countryside, are a revelation.

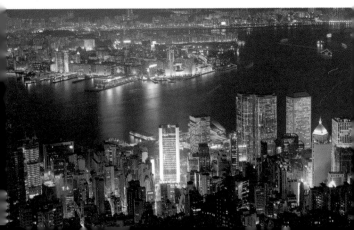

What to See

Above: the Bank of China tower
dominates the night-time sky
Right: one of the many vivid
statues in the Aw Boon Haw
(Tiger Balm) Gardens

27

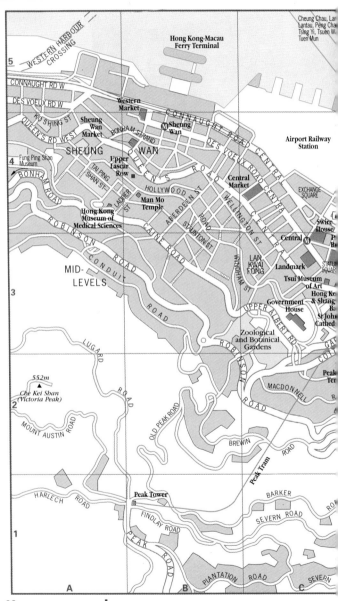

Cheung Chau, Lan
Lantau, Peng Cha
Tsing Yi, Tsuen W
Tuen Mun

Hong Kong-Macau
Ferry Terminal

WESTERN HARBOUR
CROSSING

5

CONNAUGHT RD W

DES VOEUX RD W

KO SHING ST

QUEEN'S RD WEST

Western
Market

Sheung
Wan
Market

BONHAM STRAND

Sheung
Wan

CONNAUGHT ROAD CENTRAL

DES VOEUX ROAD CENTRA

Airport Railway
Station

SHEUNG WAN

Fung Ping Shan
Museum

4

BONHAM ROAD

Upper
Lascar
Row

TAI PING SHAN ST

LADDER ST

QUEEN'S ROAD

HOLLYWOOD

Man Mo
Temple

Hong Kong
Museum of
Medical Sciences

CAINE ROAD

ABERDEEN ST

STAUNTON ST

Central
Market

WELLINGTON ST

EXCHANGE
SQUARE

Swire
House

P
B

Central

ROBINSON ROAD

CONDUIT ROAD

MID-
LEVELS

3

ROAD

WYNDHAM ST

LAN
KWAI
FONG

Landmark

STATU
SQUAR

Tsui Museum
of Art

Government
House

UPPER ALBERT RD

Hong Ko
& Shang
Ba
St Joh
Cathed

Zoological
and Botanical
Gardens

ROBINSON

GAT
CO

ROAD

Peak
Ter

LUGARD

ROAD

552m
▲
Che Kei Shan
(Victoria Peak)

2

MOUNT AUSTIN ROAD

OLD PEAK ROAD

MACDONNELL

ROAD

BREWIN

Peak Tram

ROAD

HARLECH ROAD

Peak Tower

FINDLAY ROAD

1

PEAK ROAD

BARKER ROAD

SEVERN ROAD

RO

PLANTATION ROAD

SEVERN

A

B

C

HONG KONG

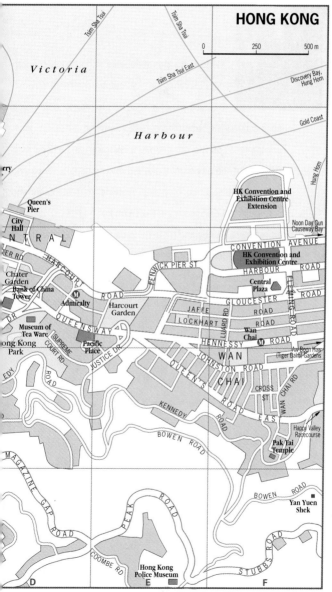

0 250 500 m

Victoria

Harbour

Tsm Sha Tsui

Tsm Sha Tsui

Tsm Sha Tsui East

Discovery Bay, Hung Hom

Gold Coast

Hung Hom

HK Convention and Exhibition Centre Extension

Queen's Pier

Noon Day Gun
Causeway Bay

City Hall

CONVENTION AVENUE

N T R A L

HK Convention and Exhibition Centre

HARBOUR ROAD

IER RD

HARCOURT

FENWICK PIER ST

Central Plaza

FLEMING ROAD

Chater Garden

ROAD

GLOUCESTER ROAD

Bank of China Tower

Admiralty

JAFFE ROAD

LUARD RD

QUEENSWAY

Harcourt Garden

LOCKHART ROAD

DR

Museum of Tea Ware

SUPREME

Wan Chai

ong Kong Park

COURT RD

Pacific Place

HENNESSY ROAD

Aw Boon Haw (Tiger Balm) Gardens

JUSTICE DR

WAN

JOHNSTON ROAD

KEDY

ROAD

QUEEN'S

CHAI

CROSS ST

WAN CHAI RD

ROAD

KENNEDY

ROAD

EAST

Happy Valley Racecourse

BOWEN ROAD

Pak Tai Temple

MAGAZINE GAP ROAD

BOWEN ROAD

Yan Yuen Shek

PEAK

ROAD

STUBBS ROAD

COOMBE RD

Hong Kong Police Museum

D E F

Hong Kong

Hong Kong at first appears a thoroughly modern city, its ranks of skyscrapers the most obvious expressions of a place where money, commerce and the headlong rush of progress seem the presiding gods. First impressions are not entirely misleading, and all you ever heard about the city's drive and energy, its superb shops and bustling streets, its cosmopolitan nightlife, its restaurants and its commercial élan has more than a ring of truth.

Yet not all is money and modernity, banks and business. Hong Kong is far older and more complex than it first appears: full of sights, sounds and smells that quickly dispel any notions that it is – or ever was – a city that gave more than a passing nod to the West. Hong Kong is Chinese through and through, from its crowded markets, with their mixture of life, colour and almost picturesque squalor, to its huge variety of festivals and the dark, incense-filled temples and shrines that lie dotted around its rumbustious streets.

> ' Hong Kong for all the world like some Spanish or Italian town with its white terraces, and coloured venetians… '

HARRY DE WINDT,
From Pekin to Calais by Land (1889)

Hong Kong Island

For most people Hong Kong Island is Hong Kong. Once home only to a handful of fishermen, its seizure by the British in 1841 was greeted with scant enthusiasm in London. Lord Palmerston, the British foreign minister, spoke with scarce-disguised disappointment of the 'barren Island with hardly a House on it'. Little could he have known what it would become.

The Peak: an essential port of call during any visit to Hong Kong Island

Today the city stretches across much of the island's northern coast, its great ranks of skyscrapers sandwiched between the harbour and the green-swathed mountains behind. At its heart lies the Central district, home to many of the most prestigious banks, hotels and shops. To the west lies Sheung Wan, a more traditional district of markets, specialist shops and occasional temples. To the east is Wan Chai, traditionally a nightlife district, but increasingly an extension of Central as redevelopment takes hold. East of Wan Chai stretches Causeway Bay, best known among visitors for its shops and hotels. Individually all of these districts can be easily explored on foot – it makes sense to devote a day or so to each – though you

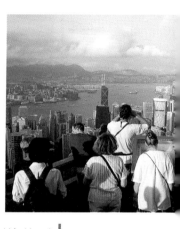

may want to use the city's cheap taxis, old-fashioned trams or sparkling modern metro system to move back and forth between them. Further afield, the Peak is an essential sight, as is the Star Ferry trip across the harbour, which, if you are staying in Kowloon, you can use to access different parts of Central and Wan Chai. Finally, don't forget the rest of Hong Kong Island: Stanley and Aberdeen are just two of the sights that lie on the island's less developed southern shores.

Hong Kong's harbour, once little more than a fishing village, is the key to the city's bustling prosperity

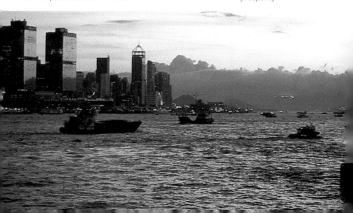

One man and a soothing menthol oil helped pay for the Aw Boon Haw Gardens

 29F3

 Tai Hang Road, Happy Valley

Daily 9:30–4

Near by (£)

Causeway Bay

Bus 11 from Exchange Square, Admiralty MTR station or Yee Wo Street

None: some steps

Free

What to See in Hong Kong Island

ABERDEEN (► 16, TOP TEN)

AW BOON HAW (TIGER BALM) GARDENS ✪

Thousands of visitors come to the Tiger Balm Gardens, ignoring their outlying position and rather dilapidated appearance in their eagerness to share the vision of one man, Aw Boon Haw. This millionaire businessman and philanthropist made his fortune through the production of Tiger Balm, a warming menthol ointment and oil designed to soothe a host of aches and pains.

The 3.5ha gardens were laid out in 1935 at a cost of many millions of dollars. Today they are rather showing their age. Many of the vivid concrete statues are cracked, their paint peeling, though their vigour, eccentricity and occasionally lurid appearance remain wonderfully intact. Most depict scenes from Chinese religion and mythology, including some graphic portrayals of sinners being tortured in the Ten Courts (or Levels) of Hell. Note the sinners in the Eighth Court, whose punishment is to be run over by a 1940s truck. One of the garden's most appealing features is the view from the six-storey Tiger Pagoda.

BANK OF CHINA TOWER ⭐⭐

The distinctly angled profile of the Bank of China Tower is one of the stars of the Hong Kong skyline: only Norman Foster's nearby Hong Kong and Shanghai Bank building rivals it for architectural ambition. Owned by the People's Republic of China, the bank provides a graphic symbol of that country's wealth and power, not to mention its determination to remain on level terms – literally and architecturally – with its capitalist rivals. Designed by the Chinese-American architect I M Pei, the bank was built between 1985 and 1990, and at 70 storeys and a height of 300m was the city's tallest structure until the arrival of Wan Chai's Central Plaza. Inside, the building reflects a classic Hong Kong juxtaposition of old and new, the entrance hall's barrel vaults recalling the style of a Ming Dynasty tomb.

Not everyone is happy with the tower, however, and there are claims that its many sharp angles, spikes and corners are at odds with the principles of *feng shui* ('wind and water'). Few buildings are built in Hong Kong without consulting a *feng shui* master, someone who understands and can advise on the machinations of the vital life force, or *qi* (*chi*). Poor design, bad positioning or the wrong alignment of a building or its interior can result in bad *chi* and bad luck. Sharp angles – such as those on the bank – produce bad *chi*. Among a number of other things considered luckier are water and mirrors. Several buildings around the new tower have been altered to block out the bad *chi* apparently emanating from the bank. Take a ride to the 73rd floor to admire the view and decide for yourself.

🔲 29D3
✉ 1 Garden Road, Central
🕐 Mon–Fri 9–5
🍴 Near by (£–£££)
Ⓖ Central
♿ Excellent
🆓 Free
↔ Chater Garden (► 40),
Hong Kong and Shanghai
Banking Corporation
Building (► 50), Old
Bank of China (► 57), St
John's Cathedral (► 59)

Did you know ?

The Chinese believe pigs' brains cause impotence; aubergines cause female infertility; snake bladder, chicken, ginseng and steamed carp are aphrodisiacs; and bird's-nest soup – the congealed saliva of cliff-dwelling cave swallows – is good for the complexion.

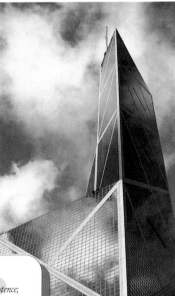

The controversial Bank of China Tower, Hong Kong's most striking piece of modern architecture

33

*Herbs, potions and other
medicinal ingredients for
sale on Bonham Strand*

 28B4

Bonham Strand and Ko
Shing Street, Sheung
Wan

Shops close on public
holidays, especially
Chinese New Year

Many cafés, food stalls
(Sheung Wan Market)
and fast-food outlets (£)

Sheung Wan

Trams to Western Market

Generally good, but poor
in places

Free

Hollywood Road (➤ 49),
Man Mo Temple (➤ 18),
Tai Ping Shan Street
(➤ 64), Upper Lascar
Row (➤ 65), Western
Market (➤ 68)

BONHAM STRAND ✪✪

Bonham Strand is one of Hong Kong Island's major
streets, beginning in Central at the end of Queen's Road
and pushing west into Sheung Wan, where it divides into
Bonham Strand East and Bonham Strand West. Well
worth exploring, it retains its appeal despite the loss of
many of its traditional sights to redevelopment.

Stores here and on surrounding streets have long
specialised in the sale of medicinal herbs and ingredients
of more dubious efficacy. Many retain their open-fronted
façades, along with shelves, drawers and glass cabinets
overflowing with a cornucopia of Chinese cure-alls. These
include bark, insects, crushed pearls, reindeer horn and
dried sea horses, not to mention highly venomous snakes
(dead and alive), which are put to both medical and gastro-
nomic use. Snake soup is a warming winter favourite – the
snake trade peaks between October and February – while
snake's gall-bladder is believed to alleviate rheumatism.
The cure involves swallowing the raw gall-bladder, recently
extracted from a live snake, with only a comforting glass of
wine to help it down. The deadlier the snake, apparently,
the more efficacious the cure.

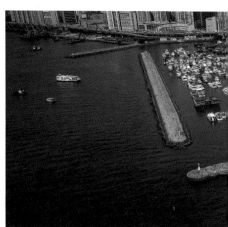

*The harbour at Causeway
Bay, a district best known
for its hotels and shops*

Less alarming but equally as potent is ginseng, 'king of the medicinal herbs', the root of a plant that grows in some 30 varieties across Southeast Asia and parts of North America. North Korea's red ginseng is particularly prized, as is the white of North America, though the most precious variety is a type gathered wild in northeast China. Ginseng is always expensive, but by the time this particular variety has been processed it retails at several hundred thousands of Hong Kong dollars an ounce.

Smarter ginseng wholesalers congregate on Bonham Strand West, along with modern bank and other business buildings. Bonham Strand East, particularly at its eastern end, is given over to cafés and shops selling more exotic – and off-putting – food and ingredients. Linger at some and you should see snakes being chosen, dispatched and prepared for consumption. Ko Shing Street is similar, and boasts many wholesalers – expect to see ingredients in baskets and bulging sacks being unloaded. Also be sure to look into the nearby Sheung Wan Market and check out the street barbers in Sutherland Street.

CAUSEWAY BAY

Causeway Bay is the most easterly of the four major districts that make up the city area of Hong Kong Island (Wan Chai, Central and Sheung Wan are the others). It has a handful of hotels, so you may be staying here, but otherwise is best known for its excellent shops and markets. Unless you are here to shop, therefore, it is unlikely you will venture this far east: the only two significant sights are Aw Boon Haw Gardens, a slightly faded folly, and the Noon Day Gun, a modest novelty immortalised in Noël Coward's song *Mad Dogs and Englishmen*. To get here, just jump on the Mass Transit Railway (MTR) or board an eastbound tram from Central or Wan Chai.

🔲 29F3

🍴 Many cafés and restaurants (£–£££)

Ⓜ Causeway Bay

♿ Good

↔ Aw Boon Haw Gardens (▶ 32), Happy Valley Racecourse (▶ 48), Noon Day Gun (▶ 56)

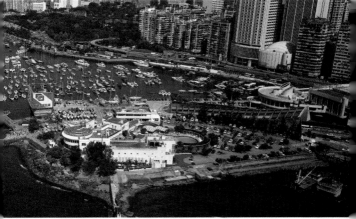

Old and new meet at the heart of Hong Kong's Central district

CENTRAL ★★★

The Central district is the heart of Hong Kong. It forms the city's financial, business and administrative core, the key banks, hotels and smart shops are here, and its ranks of high-rise buildings make up the most dramatic portion of the city's fabled skyline. Whether you're staying locally or not, it is an area you will come back to time and again. Many of the key sights are here: the Star Ferry terminal; the Lower Peak Tram Terminal (for access to the Peak) and the Hong Kong Park and its fascinating Museum of Tea Ware. So, too, are many of the key streets – Queen's Road, Des Voeux Road and Connaught Road – as well as some of the best shopping centres, notably the Landmark and Prince's Building.

For many years Central *was* Hong Kong. After the Union Jack was planted on Hong Kong Island in 1841 (on a spot a little to the west of the district's present core), the area – which became known as Victoria – developed quickly, thanks largely to its proximity to the harbour. Some of the earliest trading houses established their headquarters here, notably Jardine Matheson & Co and Butterfield & Co – their descendants retain a presence to this day – and for years the area remained a predominantly European enclave. Over the years land reclamation has

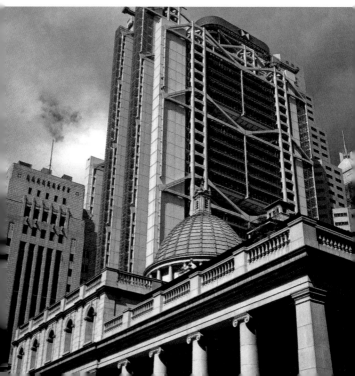

pushed the waterfront further from Central's old historic centre, though this has done little to diminish the area's importance – real estate here is still some of Asia's most expensive – nor the sense that this is the part of the city where East and West are most spectacularly combined.

Small and reasonably compact, the Central area is easily seen on foot, as is the district to the west – Sheung Wan – though you may want to take a tram to reach the key districts to the east: Wan Chai (➤ 66) and Causeway Bay (➤ 35). Crossing between Central and Kowloon across the harbour could hardly be easier – just jump aboard the Star Ferry.

CENTRAL MARKET ✪✪

The four-storey Central Market used to be Hong Kong's largest public food market, its blend of noise, colour and stench creating an overwhelming assault on the senses. These days some of its upper sections have been smartened up, though the ground floor is still home to a variety of alluring food stalls, not to mention scenes of slaughter and butchery on hapless live animals and carcasses that will turn all but the strongest stomachs. The stalls sell foods you will probably never have seen before, or at least never considered eating. Among them are salamanders, chicken's feet, sea cucumbers, lotus root – which looks like a hole-filled Swiss cheese – the foul-smelling durian fruit, and the tongues, ears, scrotums and intestines of various animals. Arrive before mid-morning if you want to sample this mélange: things begin to wind down around noon.

> ### *Did you know ?*
>
> *Among ginseng's alleged properties are its ability to cure a hangover – take white ginseng in boiled water – and the power to postpone imminent death for three days. It is administered to dying people to allow relatives time to gather at the death bed.*

Below: *not all products in the Central Market are as innocuous as these fruit and vegetables*

➕ 28C4
✉ Junction of Queen Victoria Street and Des Voeux Road
🕐 Daily 7–12
🍴 Food stalls (£)
Ⓠ Central
🚋 Trams run close to the market from Wan Chai, Central, Causeway Bay and Sheung Wan
♿ None
💷 Free
↔ Bonham Strand (➤ 34), Exchange Square (➤ 44), Sheung Wan (➤ 60, 61), Star Ferry (➤ 24), Statue Square (➤ 62)

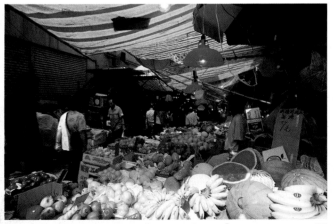

CENTRAL PLAZA ✪✪✪

At 78 storeys and 374m the Central Plaza is Hong Kong's tallest building, and until the completion of the 112-storey Petronas Tower in Kuala Lumpur (Malaysia) in 1996, was also Asia's tallest building. For a time it was the world's fifth-highest building, and still holds the record for a building made from reinforced concrete. Special plasticisers had to be added to the concrete to prevent it from solidifying as it was pumped up over 300m. Completed in 1992, it provides a potent symbol of the manner in which the glitz of Central's downtown is spreading east into the old red-light district of Wan Chai. Be sure to see Central Plaza in conjunction with another outstanding Wan Chai building, the nearby Hong Kong Convention and Exhibition Centre.

During office hours you can ride the Plaza's lifts to the Sky Lobby observation deck on the 46th floor to admire some spectacular views over the city. At ground level the building's public spaces are equally impressive, the vast 30m high lobby a palatial vision of marble, paintings and real-life palm trees. At night the Plaza's illuminated exterior and triangular glass pyramid and summit mast – which have seen it dubbed the 'Big Syringe' – make the building an unmissable feature of the city skyline. Unlike the Bank of China Tower, however, whose angles and points reputedly produce bad *feng shui* (► 33), the contractors thoughtfully rounded the edges of the Central Plaza's angles to temper any malevolent forces.

Right: *a job with a view – cleaning windows in Wan Chai*
Opposite: *Central Plaza, Hong Kong's tallest building and a superb viewpoint*

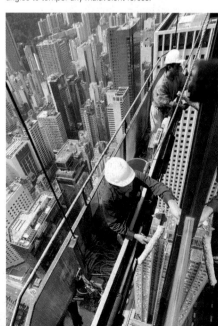

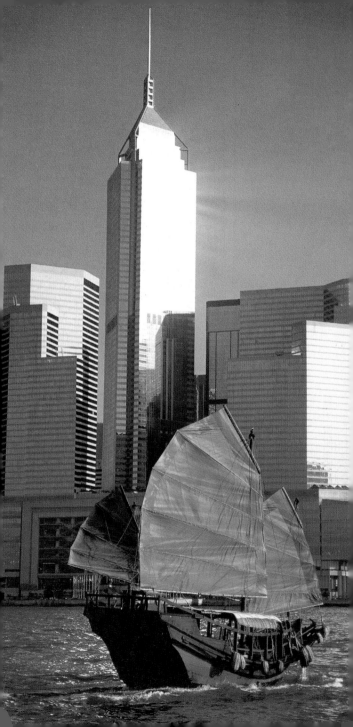

The modern city closes in on Chater Garden, once home to the Hong Kong Cricket Club

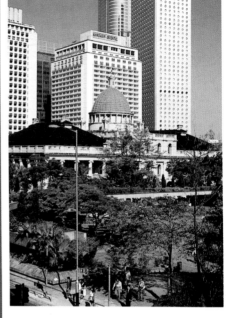

➕ 29D3
✉ Chater Road and Jackson Road
🕐 Daily 8–dusk
🍴 Near by (£)
🚇 Central
♿ Good
🎟 Free
↔ Bank of China Tower (➤ 33), Hong Kong and Shanghai Banking Corporation Building (➤ 50), Statue Square (➤ 62)

CHATER GARDEN ✪

Chater Garden occupies the site of the old Hong Kong Cricket Club, a colonial throwback that prospered amidst the high-rise of the business district until the late 1960s. That even so small a square of space has survived in so cramped a city as Hong Kong is a miracle, and one which owes its existence to the energy of local pressure groups. The Cricket Club occupied one of the world's most valuable pieces of real estate, but for once the developers came off second best to the conservationists. A modest oasis, this is a pleasant place to sit and relax, or to watch locals practising the traditional *tai chi ch'uan* exercises. The Cricket Club survives, incidentally, but now plays its matches on grounds outside the city centre.

➕ 28B4
✉ Des Voeux Road
🍴 Food stalls, cafés and restaurants (£–£££)
🚇 Central and Sheung Wan
🚊 Trams run along the length of Des Voeux Road from Central and Sheung Wan

DES VOEUX ROAD ✪✪

Des Voeux Road is Hong Kong Island's principal street after Queen's Road. Built on reclaimed land in the 1860s, it takes its name from Sir William Des Voeux, governor of the former British colony between 1887 and 1891. For much of the 19th century it formed the heart of the business district – the island's first City Hall was opened here by the Duke of Edinburgh in 1869. A short time later the Hong Kong and Shanghai Bank built their headquarters here, quickly followed by the Bank of Canton and other leading businesses.

The street still contains many company headquarters, as well as numerous prestigious shops and offices. Walk west on the street – or take the tram which runs the whole of its length – and you pass, among others, the Hong Kong and Shanghai Banking Corporation Building, the Old Bank of China and the Landmark shopping complex. Further west you encounter more traditional shops specialising in preserved foods, as well as the Central and Western markets.

Several side streets between the markets have long been known for different speciality shops, though creeping redevelopment is wiping out many of the old stores. Wing Kut Street still specialises in wholesale costume jewellery – with fantastic quantities of beads and bangles – and shops selling socks, scarves and other accessories. One street down, Wing Wo Street once specialised in feather dusters; Wing Sing Street was the haunt of egg sellers; and Wing Lok Street was the heart of the city's rice trade.

One street where tradition has survived the developers is the southern half of Man Wa Lane, where several stalls make and sell engraved seals or 'chops'. Such seals have been used for some 3,000 years as marks of ownership or in place of a signature on paintings and documents. Traders are used to visitors asking for seals to take home, and most are able to translate your name or message of your choice into Chinese characters, as well as adding a dragon, lion or other motif as an extra flourish. You can also choose the material in which the chop is made: porcelain, wood or soapstone are the most common, but ivory, bronze, marble and plastic are other possibilities. You can also decide between high or low relief: some people claim women should go for low relief (*yin wen*), men for high (*yang wen*).

♿ Mostly good
↔ Bonham Strand (➤ 34), Central Market (➤ 37), Hong Kong and Shanghai Banking Corporation Building (➤ 50), Old Bank of China (➤ 57), Western Market (➤ 68)

Des Voeux Road has been one of Hong Kong Island's principal thoroughfares for more than a century

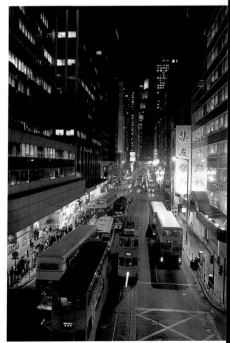

Food & Drink

'Food is heaven', suggests a Chinese proverb, a claim nowhere more justified than in Hong Kong, a city which not only has China's finest regional cooking, but also countless high-quality restaurants serving a wide range of European, North American and Asian cuisines.

The wide choice of seafood is just one of the pleasures of eating in Hong Kong

Cantonese

Chinese cooking is not a single cuisine, but rather several regional cuisines with their own flavours, ingredients and philosophies. In Hong Kong the major influences are those

of Guangdong (Canton) province, a region widely considered to offer China's best cooking and the ethnic place of origin of most Hong Kong Chinese. It also throws up some of China's most bizarre dishes, for in the past poverty meant that virtually no part of a fish, bird or animal was beyond the culinary pale. In Cantonese cooking anything that 'keeps its back to heaven' is considered suitable for the pot. Hence the chicken's feet, snakes, cockerel's testicles and other such delicacies that adorn many a Cantonese menu.

Such items are the exception rather than the rule, however, and generally Cantonese cooking concentrates on seafood, pork and chicken dishes and market-fresh vegetables. Sauces rather than spices are used to add flavour, while steaming and stir-frying are the preferred methods of cooking. The result is one of the lightest and least oily of Chinese cuisines. *Dim sum* is particularly popular, a variety of daytime snacks served from trolleys in steaming bamboo baskets.

Where to Eat

If you are not eating in a Cantonese restaurant – and the chances are you will be in Hong Kong – you may end up in a Peking (or Beijing) restaurant. Here the food is heartier – noodles and dumplings are common – the result of northern China's colder climate. Then there is Shanghai cooking, oilier, richer and sweeter than Cantonese, or Sichuan, which is decidedly hotter and spicier.

Hong Kong not only offers the best in Chinese cooking, however, for it is also a melting pot of Asian and other cuisines, the huge variety of its restaurants making it one of the world's great culinary capitals. A wide variety of Asian cuisine is available – everything from Thai, Korean and Vietnamese to Indian, Japanese and Indonesian. French and Italian restaurants are common, particularly in the big hotels, not forgetting British, German, Spanish and Greek restaurants and plenty of places offering familiar North American staples (for more on food see the panels, ➤ 92–7).

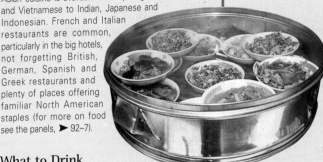

What to Drink

Chinese meals are invariably accompanied by tea, drunk without milk, sugar or lemon. Foreigners are usually served jasmine tea (*heung ping*), one of the lighter green (unfermented) teas: rose, narcissus or chrysanthemum are other possible flavourings. The Chinese usually favour a fermented tea – the Western 'black' tea – brewed as strong and oily dark as possible. Chinese beers such as San Miguel or Tsingtao are familiar lager-type brews. Chinese wines tend to be sweet and unusually flavoured, often with plants such as green bamboo leaf, rose nectar and tiger-bone papaya. Expensive French cognacs have long been popular (though more as a status symbol than a drink) and French wines – the pricier the better – are also becoming increasingly coveted.

Steaming, stir-frying and other healthy methods of cooking are used in Cantonese cuisine

Dim sum offers an easy and reasonably priced way of sampling a range of Chinese dishes

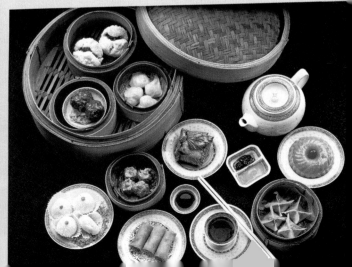

Below: *the famous buffalo fountain provides a focal point for Exchange Square*

> ## Did you know ?
> *There is a local Hong Kong tradition of never turning a fish over while eating, after a superstition of the fishing community that it will cause a fishing boat to capsize at sea.*

EXCHANGE SQUARE ✪✪

Exchange Square lies near the waterfront to the west of the Star Ferry Pier and takes its name from the Hong Kong Stock Exchange, which occupies one of the square's modern high-rise towers. The city's four separate exchanges were merged in 1986, the new single entity having taken its place with New York, London and Tokyo among the world's leading stock exchanges. The exchange moved to the square at the time of the merger, its new home the work of Swiss architect Remo Riva.

The square can seem a little austere and windswept at times – especially when empty of people – though the buildings are undeniably impressive. In good weather it's a nice place to sit and watch the world go by, especially at lunch time, when local office workers throng its precincts. The fountains and statues, some by Henry Moore, are also appealing – the big bronze water buffaloes are particular favourites. Be sure to step inside No 1 Exchange Square to admire the architecture and stunning interior waterfalls.

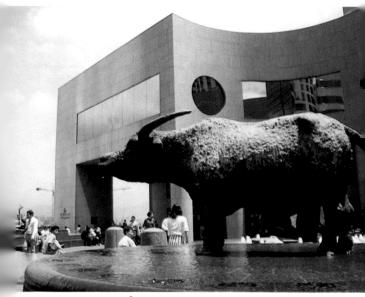

FUNG PING SHAN MUSEUM ✪✪✪

This is one of Hong Kong's most fascinating museums, all the more appealing for being little-visited and lodged in a lovely Edwardian-era building. Its highlights are some 467 Nestorian bronze crosses, the largest collection of its kind in the world: the total number of pieces – not all are shown – is almost a thousand. The crosses, found in the Ordos region of northern China, belonged to a heretical Christian sect that came to China from Syria during the Tang Dynasty (AD 618–906). The sect survived for centuries, these crosses dating from the time of the Yuan Dynasty (1271–1368). The crosses, each just a few centimetres across, vary in shape from plain crucifixes to stars, circles and swastikas. Their purpose was probably decorative, the flat back and fixed loop on each suggesting they were designed to be attached to a belt or worn as a pendant.

Elsewhere the first floor contains two other major groups of Chinese bronzes, namely 10th- to 7th-century BC pieces from the Shang and Zhou dynasties – mainly weapons and ritual vessels – and a series of bronze mirrors from the era of the Early Warring States (475–221 BC). On the second floor the emphasis is on ceramics, with pieces from virtually every period from the neolithic era to the present day. Look out in particular for the painted neolithic pottery, the Han Dynasty (206 BC–AD 220) tomb ceramics, the Han Dynasty Horse, the celebrated kiln ware (notably the china pillows) of the Song Dynasty (960–1279), the Sui Dynasty (AD 581–618) spittoons, the three-colour glazed Tang pottery (especially the camel) and the rich polychrome ceramics of the Ming and Qing dynasties (1368–1644 and 1644–1912). Recent work includes early 20th-century Buddhist monk statuettes and contemporary pieces from the noted Chinese pottery centres of Shiwan and Jingdezhen.

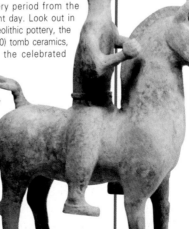

A superb pottery horse and rider from the Han Dynasty

➕ 28A4

✉ 94 Bonham Road, Hong Kong University, Sheung Wan

☎ 2975 5600

🕐 Mon–Sat 9:30–6. Closed Sun, University Foundation Day (16 Mar), public holidays

🍴 Near by (£)

Ⓜ Sheung Wan

🚌 China Motor Bus 3B from City Hall) or 23 from North Point Ferry: get off at Bonham Road opposite St Paul's College

♿ None

💵 Free

↔ Tai Ping Shan Street (► 64)

A Walk Around the Peak

Distance
3km; if you don't wish to follow the whole walk, take Lugard Road right at the Peak Café and enjoy breathtaking city views after just a few minutes

Time
50 min–1hr

Start/end point
Peak Tower
➕ 28B1

Lunch
Several cafés and snack bars in the Peak Tower and Peak Galleria (£–£££)
The Peak Café (£££)
☎ 2819 7868
Café Deco Bar and Grill, Peak Galleria (£££)
☎ 2849 5111; book ahead to be sure of tables with views

Few visitors to the Peak Tower (➤ 26) make the circuit of the Peak itself, a lovely walk with superb panoramas that offers the chance to escape the crowds for open countryside. The walk is easy to follow and virtually level for its entire length. It is also surfaced and sound under foot in all weathers.

Take the Peak Tram, taxi or bus to the Peak Tower.

Spend a few moments in the Peak Tower, where a large observation platform provides a magnificent belvedere for views over the city.

Leave the Peak Tower by the main entrance. Ignore the Peak Galleria complex opposite and turn right. After a few metres cross the road to the Peak Café, the old building shaded by trees and vegetation. To its right lies a three-road junction: Harlech Road, Mount Austin Road and Lugard Road. Take Harlech Road.

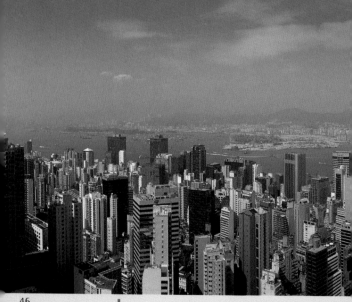

The commercialised area around the Tower soon gives way to a pleasantly shaded lane. You pass a waterfall on the right and a series of areas for different outdoor exercises. Views to your left extend across vegetation-covered slopes towards Aberdeen and Lamma Island.

After 15 minutes you come to an open area on your left with a few benches, a small shrine and more exercise equipment. Ignore the path that strikes off left here and continue straight on/right on the obvious main lane (now Lugard Road). Follow this road, ignoring any minor turns (usually private entrances to houses) until you find yourself back at the Peak Café.

The best part of the walk is reserved for the last 15 minutes, when breaks in the trees offer the finest city views anywhere in Hong Kong.

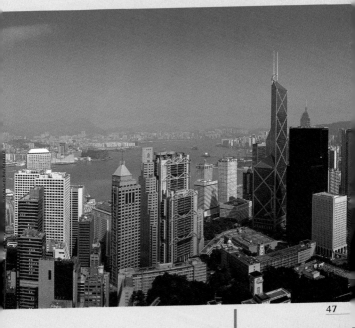

WHAT TO SEE

➕ 28C3
✉ Upper Albert Road
🕐 Closed to the public
🚇 Central
↔ Hong Kong Park (► 17),
The Peak (► 26),
Zoological and Botanical
Gardens (► 69)

*Punters weigh the odds
at the Happy Valley
Racecourse*

GOVERNMENT HOUSE ⭐

Government House was once the official residence and headquarters of the British Governor of Hong Kong, but since the handover to China in 1997 it has been earmarked for use as a museum. Begun in 1855, much of the building has been altered over the years, not least during World War II, when Hong Kong's Japanese occupiers added the oriental tower, roof corners and portico entrance. In the past the mansion's gardens were open to the public once a year (usually on a single Sunday in March). If the practice continues under Chinese rule, the gardens are well worth visiting when the azaleas and rhododendrons are in bloom.

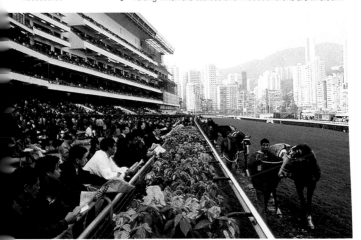

➕ 81D2
✉ 2 Sports Road, Happy
Valley. Museum: Second
Floor, Happy Valley
Stand, Happy Valley
Racecourse
☎ Racecourse: 2966 8111
or 2966 8364. Museum:
2966 8065

HAPPY VALLEY RACECOURSE ⭐

Gambling in all its forms is an obsession in Hong Kong, but only in one place on Hong Kong Island is it legal – the Happy Valley Racecourse. Situated in Happy Valley, or Pau Ma Tei, south of Causeway Bay, the course was begun in 1846. This was shortly after the valley – originally inhabited in the hope it would be more agreeable than the coast – turned out to be an area of malaria-prone marsh. Today the impressive modern course is the centre of a multi-billion dollar business administered by the Hong Kong Jockey Club. Founded in 1884, the club has long been a bastion of Hong Kong life, diverting a proportion of its profits over the years into charitable concerns around the city.

A visit here can be lots of fun, whether or not you enjoy horse-racing, thanks to the sights, sounds and fevered

atmosphere generated by some 43,000 race-goers. Real aficionados should visit the course's Hong Kong Racing Museum, whose cinema and eight galleries detail Hong Kong's 150 years of horse-racing history, or sign up for the HKTA Come Horseracing Tour (you must be over 18 and have been in Hong Kong fewer than 21 days: visit a HKTA office a day before race day and take your passport).

🕐 Race meetings: Sep–mid-Jun, Wed evenings and one weekend afternoon or evening. Museum: Tue–Sat 10–6, Sun, public holidays 1–5; race days 10–12:30. Closed Mon

🍴 Cafés, restaurants and concession stands (£–££)

🚇 Causeway Bay (Times Square exit)

🚌 75, 90 or 97 to the Hong Kong Jockey Club headquarters

♿ Good

💰 Races: moderate. Museum: free

HOLLYWOOD ROAD 😊😊

Hollywood Road and many of its surrounding streets are known primarily for their range of antique and second-hand stores. Many of the shops are aimed at visitors, though amidst the reproductions and trash you can still come across genuine treasures – gilded Buddhas, blackwood furniture, paintings, jade and ivory *objets d'art*, decorative screens, blue and white Ming porcelain and all manner of miscellaneous artefacts from across Southeast Asia. The shops are fun simply to browse, though if you are buying be sure to bargain hard and only pay top prices if you know what you are doing.

Follow Hollywood Road west and you eventually pass Possession Street (an obscure right turn), which takes its name from the fact that it was here in 1841 that Captain

Charles Elliot and a British force first claimed Hong Kong for Britain. Today the name is the event's only memorial – and may change under Chinese rule. Note how far the street is from the harbour: land reclamation has pushed the waterfront back from its mid 19th-century position.

🔲 28B4
✉️ Hollywood Road
🍴 Near by (£)
🚇 Sheung Wan
♿ Poor on steep streets
💰 Free
↔️ Bonham Strand (► 34), Hong Kong Museum of Medical Sciences (► 52), Man Mo Temple (► 18), Tai Ping Shan Street (► 64), Upper Lascar Row (► 65)

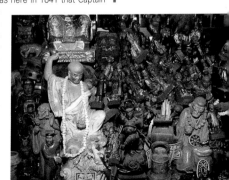

The interior of a shop on Hollywood Road, heart of Hong Kong's antiques district

✚ 28C3
✉ Des Voeux Road, Central
🍴 Near by (£–£££)
🚇 Central
♿ Excellent
🆓 Free
↔ Chater Garden (➤ 40),
 Old Bank of China
 (➤ 57), Statue Square
 (➤ 62)
❓ Access for the general
 public is limited to the
 first floor

*The Hong Kong and
Shanghai Banking
Corporation building,
flanked on the left by the
Bank of China Tower, its
main architectural rival*

HONG KONG AND SHANGHAI BANKING CORPORATION BUILDING ●●

Although this is neither Hong Kong's tallest nor most modern building, it is certainly one of its most daring and most expensive. Designed by British architect Sir Norman Foster, it was opened in 1986, having cost a reputed one billion US dollars, a significant sum even for as financially a robust organisation as the Hong Kong and Shanghai Banking Corporation, whose headquarters are served by this impressive building.

'The Bank', as it's often known, was founded by a group of Chinese merchants in 1864, and since then it has been the city's most powerful business concern. Over the years the bank has had three homes, all built on the present Queen's Road site. The first, built in 1865, was then on the waterfront, and included davits to raise and lower boats used to row to ships in the harbour. The second, built in the 1930s, was demolished in 1981 to make way for the present building. All that survive of the earlier headquarters are two famous bronze lions, nicknamed Stitt and Stephen after a pair of former chief managers. Look carefully – they stand on the pavement outside – and you can still see pock marks caused by shell fire during World War II.

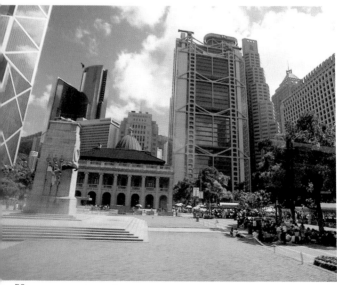

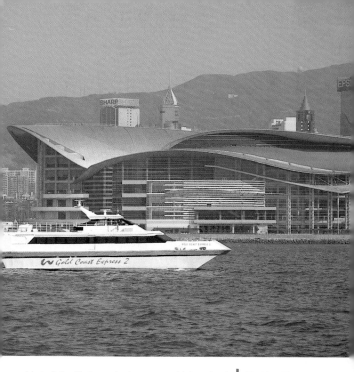

Most of the 47-storey structure was prefabricated and built elsewhere before being assembled on site. Much is constructed from glass, revealing the building's interior workings and providing dizzying prospects from many points. Despite the futuristic appearance, in which the entire edifice seems to have been turned inside out, traditional principles of geomancy were applied to satisfy the demands of *feng shui* (➤ 33): even the position of the entrance lions and the angles of the internal escalators were calculated using ancient methods.

Opinions are divided over the building's merits, but it's a striking structure by any standards. Visitors are not encouraged to enter the upper floors, but you are allowed to ride the escalators to the first floor for a revealing glimpse of the interior.

The Hong Kong Convention and Exhibition Centre, one of the city's largest and most dramatic buildings

HONG KONG CONVENTION AND EXHIBITION CENTRE ✪✪✪

Convention centres rarely feature on sightseeing itineraries, but Hong Kong's is so striking as to merit a visit in its own right. Walk up the rather unprepossessing approach – dark and cavernous – and then up into the vast airy promenade that rings the main convention halls. Here escalators and the world's largest glass curtain wall (five storeys' worth) offer spellbinding views of the harbour and city skyline. Be sure to see the centre in conjunction with the Central Plaza building just across the road.

🔳 29F3
✉ Convention Avenue, Wan Chai
☎ 2582 8888
🕐 Varies: generally open 9–6 or later
🍴 Near by (£–£££)
🚇 Wan Chai
♿ Excellent
↔ Pak Tai Temple (➤ 58), Wan Chai (➤ 66–7)

28A4
- 2 Caine Lane, Mid-Levels
- 2549 5123
- Tue–Sat 10–5, Sun, public holidays 1–5. Closed Mon
- Near by (£)
- Sheung Wan
- 26 from Des Voeux Road in front of the Hong Kong and Shanghai Banking Corporation Building to the Man Mo Temple on Hollywood Road
- Access difficult
- Cheap
- Hollywood Road (➤ 49), Man Mo Temple (➤ 18), Tai Ping Shan Street (➤ 64)
- The museum is a little hard to find: walk up Ladder Street from Hollywood and follow the signs to the right just before it emerges on to Caine Road

29E1
- 27 Coombe Road, off Stubbs Road, Wan Chai
- 2849 7019
- Tue 2–5, Wed–Sun 9–5
- Near by (£)
- Wan Chai
- China Motor Bus 15 from Exchange Square in Central: exit near Stubbs Road and Peak Road crossroads
- Poor
- Free
- The Peak (➤ 26)

HONG KONG MUSEUM OF MEDICAL SCIENCES ✪

This modest but charming little museum was opened in 1996 by Chris Patten, Britain's last governor of Hong Kong. Devoted to the historical development of medicine in Hong Kong, it owes much of its appeal to its setting, the city's former Pathological Institute, a listed Edwardian-era building. The most interesting exhibits, which range over three floors, draw parallels between the different approaches to medicine in the East and West. Lurid-coloured vitamin pills, the displays point out, look no less alarming than the various roots, barks and other ingredients used as tonics in the East.

Such tonics have long been used to restore or balance the body's levels of *qi* (*chi*) and *yin* or *yang*. More direct interventions, however, such as surgery, or the first-hand study of anatomy by dissection, were largely prohibited in the East by traditional Confucian ideas regarding the sanctity of the human body (dead or alive), ideas which in many ways hampered the development of Eastern medicine.

Cultural differences are further juxtaposed in X-rays of bones grotesquely distorted by the old custom of binding feet. Down in the basement, the crude dentist's chair and drill are almost equally shocking, the peace of the adjoining Herbalist's Room providing a calming antidote.

HONG KONG PARK (➤ 17, TOP TEN)

HONG KONG POLICE MUSEUM ✪

This outlying museum traces the history of the Hong Kong Police Force, a body formed in 1844, but with antecedents that go back three years earlier to the force of 32 ex-soldiers who accompanied Captain William Caine when he claimed Hong Kong for Britain. The most sobering exhibit is the Narcotics Room, which displays assorted drugs paraphernalia and illustrates the numerous ways drugs are smuggled. There are also a mocked-up heroin factory and a gallery filled with the weapons and ceremonial costumes associated with Hong Kong's Triad societies.

More poignant still is a flimsy rush coracle used by Vietnamese boat people to reach Hong Kong. In lighter mode are various police statements, piles of counterfeit money and the stuffed head of a tiger which was shot by a police constable in 1915.

HONG KONG

LAN KWAI FONG ⭐⭐

Lan Kwai Fong is a small area of the Central district that is becoming increasingly well known for its restaurants and nightlife. Located to the west of the Landmark shopping complex, it centres on D'Aguilar Street and Lan Kwai Fong Lane. During the day there are plenty of bars, cafés and restaurants for lunch, coffee or a snack, though the streets only really come alive after dark.

D'Aguilar Street was once known for its flower sellers, now mostly gone, who were moved here from nearby Wyndham Street, formerly called the 'Street of Flowers'. It was on Wyndham Street that Hong Kong's first English-language newspaper began publishing in 1845, earning it the nickname 'Fleet Street in miniature'. The Foreign Correspondents' Club still occupies the early 20th-century Old Dairy Farm Building at the top of the street.

MAN MO TEMPLE (► 18, TOP TEN)

 28C3
✉ D'Aguilar Street, Lan Kwai Fong Lane and Wyndham Street
🍴 Cafés, bars and restaurants (£–£££)
Ⓒ Central
♿ Poor
🔄 Central (► 36), Government House (► 48), Zoological and Botanical Gardens (► 69)

The spectacular and spacious interior of the Landmark complex in Lan Kwai Fong

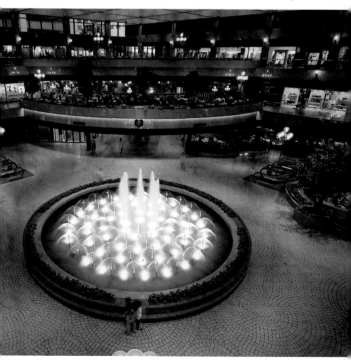

53

In the Know

If you have only a short time to visit Hong Kong, or wish to get a real flavour of the city, here are a few ideas:

10
Ways to Be a Local

Have your fortune told at one of the city's major temples.
Enjoy *dim sum* at the weekend in a busy neighbourhood restaurant.
Place a bet on the horses at the Happy Valley race track.
Take a stroll in Hong Kong Park or Kowloon Park.
Ride on the lower (not upper) deck of the Star Ferry.
Snack on huge quantities of noodles at street-corner cafés.
Use traditional Chinese medicines to cure your ills.
Yam cha – drink tea – either jasmine or the black Chinese version.
Don't always eat out – buy food and picnic supplies in local street markets.
Go to a karaoke bar after dinner.

10
Good Places to Have Lunch

Al's Diner (££) ✉ 39 D'Aguilar Street, Central, Hong Kong Island ☎ 2869 1869: great for sandwiches, snacks and typical diner meals.
BB's (££) ✉ 114–120 Lockhart Road, Wan Chai, Hong Kong Island

Have your fortune told in a variety of ways

☎ 2529 7702: smarter than most places in Wan Chai; a good alternative to the nearby Delaney's (► below).
Dan Ryan's Chicago Bar and Grill (££) ✉ 114 The Mall, Pacific Place, 88 Queensway, Hong Kong Island ☎ 2845 4600 ✉ 200 Ocean Terminal, Harbour City, Tsim Sha Tsui, Kowloon: two popular restaurants which offer first-rate burgers, ribs, fries, pancakes and other North American staples.
Delaney's (££) ✉ 2nd Floor, One Capital Place, 18 Luard Road, Wan Chai, Hong Kong Island ☎ 2804 2880 ✉ Room 1, Ground Floor, Multifield Plaza, 3–7A Pratt Avenue, Tsim Sha Tsui, Kowloon ☎ 2301 3980: two relaxed Irish-style pubs with good atmosphere, plenty of seating and up-market pub food.
Delifrance (£) ✉ Locations across the city. Like Oliver's (► below) this chain offers a tempting selection of sandwiches, filled baguettes, coffee and

cakes in familiar Western deli-style cafés.
Fauchon (£) ✉ Exchange Square, Central, Hong Kong Island ☎ 2537 2938: a smart but relaxed French-style café in Exchange Square's semicircular arcade: eat in or take way.
Oliver's (£) ✉ Locations across the city: this excellent chain of informal Western-style sandwich bars and cafés is a godsend: eat in or take away.
Peak Café (££–£££) ✉ 121 Peak Road ☎ 2819 7868: book a table with a view and you'll be assured of a memorable lunch.
The Peak (£–£££) ✉ Café Deco, 1st Level, Peak Galleria ☎ 2849 5111: several cafés in the Peak Tower and Peak Galleria offer good lunch options up on the Peak.
Yung Kee (££) ✉ 32–40 Wellington Street ☎ 2522 1624: former governor Chris Patten brought the visiting Chancellor Kohl here as his first-choice Chinese restaurant.

Best Hong Kong Views

Central Plaza: take the lifts to the mezzanine and then ride the elevators to the 46th floor for some vertiginous bird's-eye views (➤ 38).

Hong Kong Convention and Exhibition Centre: this building provides superb vistas of the harbour and city skyline (➤ 51).

The Peak: take the Peak Tram to the Peak Tower and then walk around the Peak (➤ 26 and walk ➤ 46).

Star Ferry: ride across the harbour for superb views of the city skyline; make two trips – one during the day and one at night (➤ 24).

Waterfront Promenade: stroll behind the Cultural Centre for views across the harbour to Hong Kong Island. Twilight here is especially magical (➤ 79).

Evening Activities

• Sign up for a HKTA evening cruise in the harbour, or to Aberdeen or Repulse Bay.

• Go window-shopping on Nathan Road or the malls of Tsim Sha Tsui East and Causeway Bay.

• Visit the Peak at night or ride a tram run across the city.

• Visit a night market such as Temple Street (Kowloon) or Jardine's Crescent (Hong Kong Island).

• Ride the Star Ferry or walk waterfront promenades in Kowloon for views of the city across the water.

Top Activities

Golf: the Discovery Bay Golf Club has an 18-hole course on Lantau Island (☎ 2987 7271); the Hong Kong Golf Club offers three 18-hole courses at Fanling in the New Territories (☎ 2670 1211); and the Tuen Mun Golf Centre has a practice green and a 100-bay driving range (☎ 2466 2600). The HKTA Sports and Recreation Tour includes the chance to play at the Clearwater Bay Golf Club course in the New Territories (☎ 2807 6177).

Hiking: contact HKTA offices (☎ 2807 6177) for details of short walks or the longer Hong Kong Trail (50km); Lantau Trail (three days); MacLehose Trail (100km); and Wilson Trail (78km). Climbers should call the Mountaineering Union (☎ 2747 7003) or Mountaineering Association (☎ 2391 6892).

Rugby: Hong Kong's annual Rugby Union 'Sevens' are internationally

The famous Hong Kong 'Sevens' Rugby tournament is one of the highlights of the city's sporting year

renowned: for more details of the event and rugby in the city, contact the Hong Kong Rugby Football Union, Sports House, 1 Stadium Path, So Ko Po, Happy Valley (☎ 2504 8300).

Tennis: public courts are always heavily booked; try your luck at Victoria Park (☎ 2570 6186), Bowen Road Sports Ground (☎ 2528 2983), the Tennis Centre (☎ 2574 9122) and Kowloon Tsai Park (☎ 2336 7878). Also contact the Hong Kong Tennis Association (☎ 2504 8266).

Windsurfing: several beaches offer board rentals, notably Stanley Beach (➤ 23) and Shek O on Hong Kong Island, and Tun Wan Beach on Cheung Chau island. Also contact the Hong Kong Windsurfing Association (☎ 2504 8255).

Betting and horse-racing are Hong Kong obsessions

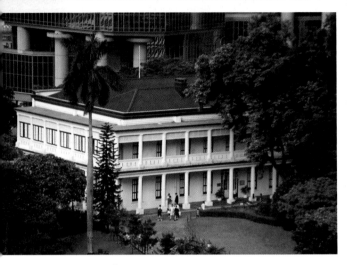

Above: *Flagstaff House, home to the Museum of Tea Ware*

MUSEUM OF TEA WARE ⭐⭐

You could spend a happy hour in this quaint museum, as the 500-piece collection of tea ware is more interesting than it sounds. Much of the museum's appeal derives from its setting, Flagstaff House, a fine old building with high ceilings and bright wooden floors, built in stately style in 1846 as the residence of the former commander-in-chief of Hong Kong's British garrison. (Hong Kong Park, which surrounds the museum, was once the Victoria Barracks and is also well worth a visit (➤ 17). Today the house is the city's oldest surviving colonial building.

The collection was accumulated by Dr K S Lo and left to the city in the 1970s. Beautiful teapots and all manner of other tea-making paraphernalia are the star turns, some of which may date back as far as the 5th century BC. Look out in particular for the famous Yi Xing ware from China's Jiangsu Province. Also be sure to browse in the museum shop, where you can buy a tempting range of teas and reproduction and contemporary teapots.

NOON DAY GUN ⭐

The Noon Day Gun is an insignificant little thing – a small recoil-mounted, brass-bound Hotchkiss three-pounder built in 1901. It's also housed in an insignificant little spot – a garden just outside the Excelsior Hotel. It's achieved a fame far beyond its size, however, thanks to the lines in Noël Coward's famous song, *Mad Dogs and Englishmen*: 'In Hong Kong/They strike a gong/And fire off a noonday gun…'

The gun is still fired daily at noon, though how the tradition began is something of a mystery. One theory suggests it was fired to welcome William Jardine, co-founder of Jardine, Matheson & Co, as he arrived by boat

at the nearby East Point. A naval officer, angry that the gun had been used for such a purpose, ordered the battery to use up its ammunition in a daily noontime signal. Another story claims the Navy was cross because its function as official signaller had been usurped, or that a signal had been given when it was not merited. Either way, the Jardine company was ordered to fire a noontime signal for evermore as a daily penance. Whatever the story, the gun is still fired, not only at noon, but also at midnight – by sprucely dressed Jardine employees – on New Year's Eve.

Some harbour tours are timed to be in the locality for the noon firing: contact the Hong Kong Tourist Association. Otherwise, it is not really worth making a special journey.

No one is quite sure of the original reason for the firing of the famous Noon Day Gun

OCEAN PARK (➤ 20, TOP TEN)

OLD BANK OF CHINA ✪
The Old Bank of China stands just west of the new Bank of China Tower, a stolid stone edifice built by the Chinese after World War II, and easily recognisable by the Chinese lions guarding its entrances. It was surely no accident that it was built some 6m higher than the old Hong Kong and Shanghai Bank building, or that the new Bank of China Tower – built after the new Hong Kong and Shanghai Bank building – was also higher than its long-term rival (➤ 50).

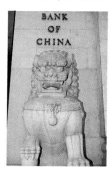

🚑 29D3
✉ Jackson Road–Des Voeux Road, Central
☎ 2868 2688
🕐 Closed to the public
🍴 Near by (£)
Ⓜ Central
🎟 Free
↔ Chater Garden (➤ 40), Hong Kong and Shanghai Banking Corporation Building (➤ 50), Statue Square (➤ 62)

Ancient Chinese lions stand guard outside the Old Bank of China building

57

+ 29F2
✉ Lung On Street, a left
turn off Stone Nullah
Lane 150m south of the
junction of Queen's Road
East and Wan Chai Road
🕐 Daily 7–6
🍴 Near by (£–£££)
🚇 Wan Chai
🚃 15 or 260; eastbound or
westbound trams to
Johnston and Wan Chai
roads
♿ None: a few steps
✋ Free but donations
welcome
↔ Central Plaza (▶ 38),
Hong Kong Convention
and Exhibition Centre
(▶ 51), Wan Chai
(▶ 66–7)

*The colourful exterior of
the Pak Tai Temple*

PAK TAI TEMPLE

Any tour of Wan Chai should take in this homely little temple, tucked away a couple of minutes' walk from Queen's Road East. Built during the 1860s, the temple, its façade blackened from years of incense burning, is dedicated to Pak Tai, a military god invoked to bring peace. A 17th-century copper statue of the god, adorned with real hair and richly embroidered clothes, sits on a throne at the heart of the temple. Flanking him stand four statues representing scholars and warriors.

Be sure to peek into the main room off the temple, home to craftsmen making traditional paper and bamboo burial offerings, exquisite little models designed to represent objects the deceased might require in the afterlife. They are also intended as a reflection of the wealth and prestige he or she enjoyed in life. Although the tradition is centuries old, these days the models are likely to include such things as Rolls-Royces, portable phones and video recorders. The models are collected and burnt at the funeral to accompany the deceased to heaven.

THE PEAK (▶ 26, TOP TEN)

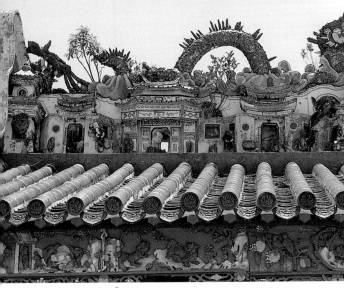

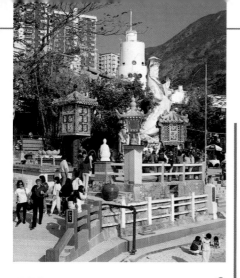

Repulse Bay can get very crowded in the peak summer months

REPULSE BAY ⭐

For most visitors Repulse Bay will be no more than a sudden blur of beaches and buildings as they head for Stanley to the west. The area takes its name from a British warship, HMS *Repulse*, and for decades was famous for the luxury Repulse Bay Hotel, a British army headquarters in 1941 (to the Army's shame the Japanese climbed over the hills to its rear and took the hotel after walking through its gardens). The old hotel was pulled down in 1982.

The beach is pleasant enough – more than can be said for the cafés at its fringe – and is busy in summer, though the water quality is too poor for swimming (check, too, that the special shark net is in place). Shek O, on the east coast of Hong Kong Island, is the best place to head for if you want to spend time on a Hong Kong beach.

 81D2
🍴 Near by (£–£££)
🚌 Buses 6, 6A and 6X run to Stanley via Repulse Bay from Central's Exchange Square terminal
♿ Few
↔ Stanley (➤ 23)
❓ If you take the bus sit on the top deck to enjoy the view

ST JOHN'S CATHEDRAL ⭐⭐

This Anglican cathedral is one of only a handful of buildings recalling the 19th-century heyday of British rule. Built in 1849 in Victorian-Gothic style, it is probably the Far East's oldest Anglican church, though it was badly damaged in World War II, when it served as an officers' club during the Japanese occupation. Many of the old memorial tablets and virtually all the stained-glass windows were lost. Now restored, the cathedral survives as a peaceful retreat from the capitalist frenzy of the surrounding streets.

Note the main doors, salvaged from the timbers of HMS *Tamar*, a British naval supply ship that arrived in Hong Kong in 1878 and remained in the harbour for over 50 years. It was scuttled in 1941 to prevent it from falling into Japanese hands, and for a time lent its name to part of the harbour. Between 1897 and 1993 this area was the British navy's Hong Kong headquarters: now only a 28-storey building and small harbour remain of a dockyard that once stretched to the Wan Chai waterfront to the east.

🔲 28C3
✉ Garden Road, Central
🕐 Daily 7:30–6
🍴 Near by (£)
🚇 Central
♿ Good
🎫 Free
↔ Chater Garden (➤ 40), Hong Kong and Shanghai Banking Corporation Building (➤ 50), Hong Kong Park (➤ 17), Lower Peak Tram Terminal for the Peak (➤ 26), Museum of Tea Ware (➤ 56), Old Bank of China (➤ 57)

*Above: Sheung Wan is
well known for shops
selling specialist foods
and Chinese medicines*

SHEUNG WAN DISTRICT ✪✪✪

Sheung Wan, the area to the west of Central, is not the most westerly of Hong Kong Island's city districts – Sai Ying Pun and Kennedy Town lie further west – but is about as far as most visitors venture during their stay. An area of traditional streets and trades, it begins almost immediately beyond the Central Market, though like other areas on the fringes of Central – notably Admiralty and Wan Chai – its old buildings are increasingly having to make way for modern skyscrapers.

Certain traditional enclaves survive, however, most of which you can visit during the course of a morning's walk. One of the key areas centres on Bonham Strand and Ko Shing Street, heart of the city's wholesale trade in traditional medicines. Another focuses on Hollywood Road, centre of the art and antiques district and home to the Man Mo Temple, the most impressive of the city's temples. Close by lies Tai Ping Shan Street, where three smaller but equally interesting temples survive.

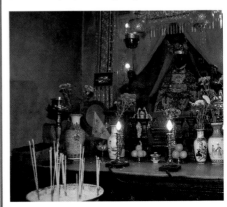

*Right: the Man Mo
Temple is the highlight of
any visit to Sheung Wan*

Around the Sheung Wan District

Walk west from the Central Market on Des Voeux Road and turn left up Wing Kut Street (seventh on the left). Turn right on Queen's Road Central, right again on to Bonham Strand, and right again shortly afterwards down Man Wa Lane.

Old trades and traditions still survive despite the extensive redevelopment taking place around the Central Market: Wing Kut Street is known for its cheap jewellery stalls while Man Wa Lane is home to 'chop' or seal makers.

Turn left on Des Voeux Road and left at Morrison Street. Then turn right on Bonham Strand East and bear right as it becomes Bonham Strand West. At the end turn left and left again at the fork down Ko Shing Street.

At the top of Morrison Street look into the Western Market. Bonham Strand and Ko Shing Street are full of fascinating stores selling ginseng and traditional medicine.

Turn left at the end of Ko Shing Street onto Des Voeux Road West and then left on Wilmer Street to Queen's Road West. At the bend left take a right turn onto Hollywood Road.

Hollywood Road is full of interesting shops selling antiques, coffins, curios and bric-à-brac. Look out for Possession Street on the left, where Hong Kong was claimed for Britain in 1841.

Turn right up Pound Lane just after Possession Street for the simple temples on Tai Ping Shan Street. Otherwise continue along Hollywood Road to Man Mo Temple. Just before the temple Ladder Street to the right will take you towards the Hong Kong Museum of Medical Sciences.

Distance
2km to Man Mo Temple, 3.5km to Lan Kwai Fong and including the diversion to the Museum of Medical Sciences

Time
Allow a morning

Start point
Central Market
➕ 28C4

End point
Man Mo Temple or Lan Kwai Fong
➕ 28B4

Lunch
Follow Hollywood Road beyond the Man Mo Temple and continue on Wyndham Street. Turn left at the end into the small grid of streets around Lan Kwai Fong, which contains many cafés and restaurants

Sheung Wan's Hollywood Road specialises in antiques and objets d'art

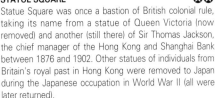

✚ 28C3
✉ Chater Road
🍴 Near by (£–£££)
🚇 Central
♿ Excellent
↔ Bank of China Tower
(➤ 33), Chater Garden
(➤ 40), Hong Kong and
Shanghai Banking
Corporation Building
(➤ 50), Old Bank of
China (➤ 57), Star Ferry
(➤ 24)

Below: *the bronze figure
of bank manager Sir
Thomas Jackson*
Opposite: *the Legislative
Council Chamber*

STANLEY (➤ 23, TOP TEN)

STAR FERRY (➤ 24, TOP TEN)

STATUE SQUARE　　　　　　　　　　　★★

Statue Square was once a bastion of British colonial rule, taking its name from a statue of Queen Victoria (now removed) and another (still there) of Sir Thomas Jackson, the chief manager of the Hong Kong and Shanghai Bank between 1876 and 1902. Other statues of individuals from Britain's royal past in Hong Kong were removed to Japan during the Japanese occupation in World War II (all were later returned).

Today most of the old colonial buildings have gone, as have the harbour views enjoyed when the square's northern flank looked out over the waterfront (land reclamation has long since changed its appearance). The only building of any age is the Legislative Council Chamber, a grandiose granite edifice with lofty Ionic pillars and pinnacled dome on the square's eastern flank. It was completed around 1910 and designed by Sir Aston Webb, the British architect responsible for the façade of Buckingham Palace and the Victoria and Albert Museum in London. Until 1985 it was the city's Supreme Court, hence the pediment statue of the blindfolded Greek goddess Themis, symbol of law and justice.

Today the area is hardly a square in the accepted sense, having been spoiled by the sterility of its modern surroundings, concrete pools and lacklustre fountains. Nonetheless it's a favoured Sunday meeting place for some of the city's expatriate workers – Filipinos in particular – and provides visitors with a good point from which to admire nearby buildings such as the Bank of China Tower, Old Bank of China and the Hong Kong and Shanghai Banking Corporation Building.

The War Memorial Cenotaph, a memorial to the Hong Kong dead of two world wars, is also here (just across the road), as is the home of the Hong Kong Club, a 'paradise of the select, and temple of colonial gentility'. The club's elegant old headquarters, a rococo building dating from 1898, was torn down in the late 1970s. It now occupies several floors of a modern tower.

TAI PING SHAN STREET ✪✪

Tai Ping Shan means the 'Peaceful Mountain' – a reference to the Peak – and was one of the first areas of Hong Kong Island to be settled by the Chinese after the creation of the former British colony. It quickly became infamous for overcrowding, poor housing and frequent outbreaks of disease, as well as a breeding ground for some of the first of Hong Kong's notorious Triad societies.

Today its western end conceals a group of fascinating little temples, while its eastern margins are a warren of steep alleys, markets, workshops and dilapidated housing complexes. The temples are easy to miss, looking like little more than open-fronted homes: but coils of burning incense are a clue. The first is the tiny Kuan-yin shrine, dedicated to the goddess of mercy and frequented by mothers praying for fertility or the well-being of children and the resolution of domestic disputes. The image of the goddess is said to have been carved by the founder's wife, the original wooden block having reputedly been found in the sea emitting an unearthly golden light.

The Sui-tsing Paak Temple (the 'Pacifying General') is dedicated to the eponymous god, one renowned for curing disease, whose statue was brought here during a plague epidemic in 1894. The temple also contains rows of *Tai Sui*, statues representing 60 different gods associated with the 60-year cycle of the Chinese calendar. People come here to pray to the god linked to the year of their birth.

The most fascinating temple is Paak Sing, literally the 'Temple of a Hundred Surnames', first built in 1851 as a hospice for the dying. With death in the family home considered unlucky, it was not unusual in the 19th century for the dying to be abandoned on Hong Kong's hillsides. The hospice was rebuilt in 1895 after the surrounding quarter was levelled following an epidemic. It is now dedicated to family ancestors, this type of temple generally

Women hoping to ensure fertility leave oranges and other votive offerings in the Kuan-yin Temple

Detail from the Sui-tsing Paak Temple in Tai Ping Shan Street

being reserved for a single family or clan group, whose dead would be laid out awaiting burial elsewhere. Such temples would also hold ancestral 'soul tablets', small boards – similar to Christian headstones – giving the name and date of birth of the deceased. This temple is unusual in being open to all, and contains some 3,000 age-worn tablets, some with photographs of the dead.

Alongside the Paak Sing Temple lies the Tin Hau shrine, dedicated to the Queen of Heaven or goddess of the sea, an understandably popular deity given Hong Kong's maritime traditions: most fishing and other local boats in the harbour are adorned with her image.

TSUI MUSEUM OF ART ✪✪✪

This excellent little museum is one of Hong Kong's best-kept secrets. Rotating exhibits from the private 3,000-piece collection offer the chance to admire some of Asia's finest Chinese art and artefacts. Ceramics spanning several centuries form the collection's cornerstone, though other outstanding pieces include furniture, bronzes, ivories, wooden carvings and some impressive Han Dynasty tomb statues.

- ✚ 28C3
- ✉ 5 Queen's Road Central
- ☎ 2868 2688
- ⏰ Mon–Fri 10–6, Sat 10–2. Closed Sun, public holidays
- 🍴 Near by (£)
- Ⓒ Central
- ▥ Moderate

UPPER LASCAR ROW ✪

Close to Hollywood Road and Man Mo Temple, the street is known for its flea market – selling little more than glorified junk – and for smarter galleries and antique shops midway down the street. Among the latter the best known are the Cat Street Galleries, a complex of shops selling arts, crafts and antiques.

The district has been known for antiques and bric-à-brac since 1949, when thousands of Chinese fleeing the mainland Communist revolution came here to sell or pawn family heirlooms. The story of the street and its nickname – 'Cat Street' – goes back further: 'Lascar' is Urdu for an east Indian seaman, probably because the area contained lodgings used by foreign seafarers. 'Cat' may come from the fact that everything sold here had been stolen by cat burglars, or from the local brothels that sprang up in the area to accommodate visiting sailors.

- ✚ 28C3
- ✉ Sheung Wan
- ⏰ Cat Street Galleries: Mon–Sat 9–6, Sun 11–5
- 🍴 Near by (£)
- Ⓢ Sheung Wan
- ♿ Poor
- ▥ Free
- ↔ Hollywood Road (➤ 49), Hong Kong Museum of Medical Sciences (➤ 52), Man Mo Temple (➤ 18), Sheung Wan (➤ 60–1)

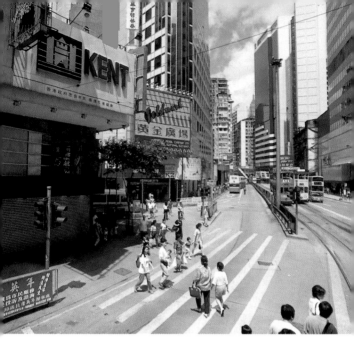

*Redevelopment is altering
the face of the Wan Chai
area, traditionally one of
Hong Kong's main
entertainment districts*

WAN CHAI ✪✪✪

Wan Chai is Hong Kong's best-known district after Central,
its fame partly the result of Richard Mason's *The World of
Suzie Wong*, a book that chronicled the life and loves of a
Wan Chai prostitute (a film was also made). The area was
the first of five *wan*, residential quarters set aside by the
British for the Chinese; Central, or Victoria as it was then
known, was reserved largely for Europeans. British military
barracks were later installed, and where soldiers came,
prostitutes soon followed.

Wan Chai's reputation as a red-light district prevailed for
years, achieving its greatest notoriety during the Korean
and Vietnam wars, when its bars, brothels and clubs were
favoured points of 'rest and relaxation' for off-duty
servicemen. Today the streets still have the slightly seedy
look of the 1950s and 1960s, full of dark alleys and
crumbling tenements, not to mention a preponderance of
bars, clubs, British 'pubs' and hostess 'establishments'.
Sailors on shore leave, locals and curious tourists still
prowl the night-time streets, though the area's sex,
salaciousness and earthy vigour are now either memories
or have been sanitised for public consumption.

The district is still well worth seeing, however, both by
day and night. Conventional 'sights' are few, but try to
spend time exploring Lockhart Road – focus of the nightlife
– or the wonderful grid of old-fashioned streets between
Johnston Road and Queen's Road East. Newer buildings
worth seeing include Central Plaza (► 38) and the Hong
Kong Convention and Exhibition Centre (► 50).

Around the Wan Chai District

Turn right on Gresson Street off Johnston Road. At the top turn left on Queen's Road East. Turn left down the narrow Tai Wong Street West then double back to Queen's Road East on Tai Wong Street East.

Gresson Street has a vibrant street market, while Tai Wong Street West boasts a few shops selling caged songbirds. On the south side of Queen's Road stands the Hung Sheng Temple, which is dedicated to Hung Sheng, protector of fishermen.

Walk east on Queen's Road East to the junction with Wan Chai Road. Turn right here on Stone Nullah Lane and walk about 150m to the top of the street. Turn left at the trees and Pak Tai Temple is on the right. Retrace your steps and walk north on Wan Chai Road. After about 150m turn left on Cross Street and then right on Tai Yuen Street to Johnston Road.

Note the old Wan Chai Post Office (1915), a white building on the south side of Queen's Road East. Detour to the Pak Tai Temple and visit the Wan Chai market on the corner of Wan Chai Road and Queen's Road East. Cross Street and its surrounding alleys contain one of the city's best street markets.

Walk west on Johnston Road, turn right on Lugard Road and then right on Lockhart Road. Turn left on O'Brien Road and cross Gloucester Road to the Central Plaza complex. Cross Harbour Road and bear left to the Hong Kong Convention and Exhibition Centre.

Note people playing mahjong and other games in the Southern Playground on Johnston Road. Take in the clubs and bars on Lockhart Road and then visit Central Plaza and the Convention Centre.

Distance
2.3km

Time
2–3 hours, depending on stops

Start point
Junction of Johnston Road and Queensway
✚ 29E3
🚇 MTR to Wan Chai then walk 400m west on Hennessy Road to Johnston Road
🚃 Take any tram eastbound from Central (Des Voeux Road) or westbound from Causeway Bay (Hennessy Road) and get off at the point where the tram leaves the main west–east line of Des Voeux–Hennessy Road at Johnston Road

End point
Hong Kong Convention and Exhibition Centre
✚ 29F3

Lunch
Delaney's (£–££)
✉ 2nd Floor, One Capital Place, 18 Lugard Road: entrance is on Jaffe Road near Lugard Road
☎ 2804 2880
❓ Book or arrive early to be sure of a table (opens at 12)

An outdoor fish stall on Wan Chai Road

+ 28B5
✉ New Market Street/
Connaught Road Central,
and Morrison Street,
Sheung Wan
⏰ Daily 10–7
🍴 Cafés and food stalls (£)
🚇 Sheung Wan
♿ Poor
↔ Central Market (➤ 37),
Hollywood Road (➤ 49),
Man Mo Temple (➤ 18),
Sheung Wan (➤ 60–1)

+ 29F1
✉ Bowen Road
⏰ Daily 7–dusk
🍴 Near by (£)
🚇 Wan Chai
♿ Poor
🎟 Free
↔ Happy Valley Racecourse
(➤ 48), Hong Kong
Police Museum (➤ 52),
Wan Chai (➤ 66–7)
❓ For Lover's Rock, exit the
Zoological Gardens by the
aviaries; cross Garden
Road, turn left on
Magazine Gap Road, then
left on Bowen Road

*Western Market is good
for arts and crafts*

WESTERN MARKET

After restoration in 1991 the Western Market retained its
1906 Edwardian shell but lost the Chinese food market
that had flourished here for well over 80 years. With it
went local colour and charm, to be replaced by a lifeless
two-floor mall of shops, those on the ground floor devoted
to arts and crafts, those on the upper level given over
mostly to fabrics (an excellent place to buy materials). If
you prefer the sights and sounds of a real market, walk a
couple of minutes south on Morrison Street to the Sheung
Wan Market. Stalls here sell meat, fish and the full range
of colourful Chinese foods. Upstairs, if you're adventurous,
you can buy food from stalls to eat on the move.

YAN YUEN SHEK

From the Zoological and Botanical Gardens (➤ 69) you
may want to visit a minor Hong Kong landmark, Yan Yuen
Shek, better known as the Lover's Rock. The 9m rock is
visited by women in search of an ideal husband, particu-
larly on the 6th, 12th and 26th days of the lunar month,
days considered particularly propitious among the Chinese
for this type of activity. It is located amidst the strange
Lover's Stone Garden, a pleasant 20-minute walk from the
Zoological and Botanical Gardens.

Apart from the rock, the garden features all manner of
stones covered in paper offerings and sandboxes filled
with smoking joss sticks and votive gifts of incense. Look
out in particular for the little clusters of paper windmills,
believed by the Chinese to symbolise a change of fortune.
Also likely to be in attendance are groups of incense-
sellers and fortune-tellers, the latter guaranteed a captive
audience among the many lovelorn, lost or desperate
souls who visit the shrine.

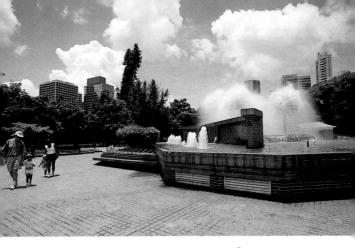

ZOOLOGICAL AND BOTANICAL GARDENS ✪✪✪

Although not as central as Hong Kong Park, these lovely gardens are equally appealing as a retreat from the rigours of traffic, crowds and city sightseeing. Once harbour views would have added to their charm, but since the Gardens were opened in 1864 the waterfront panorama has been replaced with ranks of mirror- and glass-fronted skyscrapers (views of the Bank of China Tower from here are especially good).

Pathways thread through banks of shrubs, trees and semi-tropical plants, taking in a large aviary *en route*, whose 300 or more species of birds include cranes, toucans, flamingos and other exotica. The aviary has achieved particular renown as a breeding centre, helping save many species on the edge of extinction. There is also a greenhouse complex, among whose highlights are various insectivorous plants such as the Venus fly-trap.

During your ambles be sure to look out for the statue of Sir Arthur Kennedy, the ground-breaking British governor (1872–7) – he was the first to invite the Chinese to official functions.

The gardens are twinned with a zoo to the west, (reached via an under-pass), a considerably less appealing proposition, thanks mainly to the relatively poor conditions in which animals are kept. The cages and conditions were improved in 1996, but matters are still far from satisfactory.

➕ 28C3
✉ Corner of Upper Albert Road and Garden Road, opposite Government House
☎ 2530 0155
🕐 Daily 6AM–10PM
🍴 Near by (£)
Ⓜ Central
🚌 3 or 12 from Jardine House and other stops on Connaught Road to the Caritas Centre at the junction of Upper Albert and Caine Roads
♿ Good (some steep approaches)
🆓 Free
↔ Government House (►48), Hong Kong Park (►17), Museum of Tea Ware (►56), the Peak (►26)
❓ The gardens have several entrances: from Central the most accessible is on Upper Albert Road

Above: the plaza and central fountain of the Botanical Gardens
Left: a statue of George VI recalls the era of British rule in Hong Kong

69

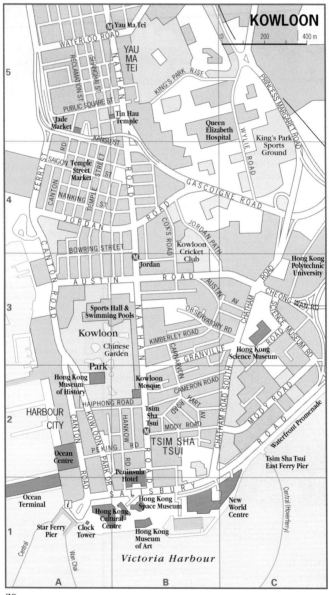

KOWLOON

200 400 m

5

WATERLOO ROAD

M Yau Ma Tei

YAU MA TEI

KING'S PARK RISE

PRINCESS MARGARET ROAD

RECLAMATION ST.

SHANGHAI ST.

NATHAN

PUBLIC SQUARE ST.

Jade Market

Tin Hau Temple

KANSU ST.

Queen Elizabeth Hospital

WYLIE ROAD

King's Park Sports Ground

SAIGON ST.

Temple Street Market

CANTON RD

NANKING ST.

TEMPLE STREET

FERRY ST.

ROAD

GASCOIGNE ROAD

4

JORDAN

COX'S ROAD

JORDAN PATH

ROAD

BOWRING STREET

M Jordan

Kowloon Cricket Club

Hong Kong Polytechnic University

CANTON ROAD

AUSTIN

ROAD

AUSTIN AV.

CHATHAM ROAD

CHEONG WAN RD

3

Sports Hall & Swimming Pools

NATHAN

OBSERVATORY RD

SCIENCE MUSEUM RD

Kowloon

Chinese Garden

KIMBERLEY ROAD

CARNARVON

Hong Kong Science Museum

Park

GRANVILLE

Hong Kong Museum of History

Kowloon Mosque

CAMERON ROAD

HAIPHONG ROAD

Tsim Sha Tsui

GWOB

HART AV.

CHATHAM ROAD SOUTH

MODY ROAD

2

HARBOUR CITY

CANTON ROAD

KOWLOON PARK DR

HANKOW RD

M

MODY ROAD

Waterfront Promenade

Ocean Centre

PEKING RD

TSIM SHA TSUI

Tsim Sha Tsui East Ferry Pier

Peninsula Hotel

SALISBURY

Central (Hoverferry)

1

Ocean Terminal

i

Hong Kong Cultural Centre

Hong Kong Space Museum

New World Centre

Star Ferry Pier

Clock Tower

Hong Kong Museum of Art

Central

Wan Chai

Victoria Harbour

A B C

Kowloon

Kowloon is the peninsula that drops down from the Chinese mainland and looks across the city's harbour to Hong Kong Island. Its name comes from *gau lung*, or 'nine dragons', after the tale that in the 13th century a boy-emperor fled here to escape the Mongols and counted eight hills, supposedly the home of eight dragons. The boy's sycophantic advisers rounded the figure up to nine, pointing out the emperor himself was a dragon.

Like Hong Kong Island, Kowloon is divided into various districts, though most visitors will venture little further than Tsim Sha Tsui ('sharp, sandy point'), the area on the peninsula's southernmost tip. Many of the main hotels are here, together with most of the key shops, restaurants and nightlife – Nathan Road, in particular, is one of the city's most famous, if not most compelling shopping streets. Many of Kowloon's key sights are also here – notably the Art, Science and History museums – most of them within easy walking distance of one another.

> *'Vice must be pretty much the same all the world over, but if a man wishes to get out of pleasure with it, let him go to Hong Kong.'*
>
> RUDYARD KIPLING,
> *From Sea to Sea* (1889)

What to See in Kowloon

CLOCK TOWER ✪
Once, the colonial-style splendour of the old Kowloon–Canton Railway Station would have greeted passengers disembarking at Tsim Sha Tsui's Star Ferry Pier. Built in 1916, the station was the southern terminus of a line that proceeded to Beijing (Peking), ultimately allowing passengers to travel as far as Paris, London and Moscow by way of Russia, China and Mongolia. Today all that remains is the 45m clock tower (1921), the station having been demolished in 1978 to make way for the Hong Kong Cultural Centre. The station has since been relocated to the Hung Hom area northeast of Tsim Sha Tsui.

HONG KONG CULTURAL CENTRE ✪✪
Hong Kong's striking and controversial Cultural Centre lies just a short distance from the Star Ferry Pier, making it one of the first things you see in Kowloon after crossing from Hong Kong Island. Within or close to its confines lie two of the area's outstanding sights – the Hong Kong Museum of Art and the Hong Kong Space Museum: the $600 million landmark building, however, deserves attention in its own right.

The centre was opened in 1989 by Princess Diana and Prince Charles, and it replaced the old Kowloon–Canton Railway Station, torn down in 1978. The new building created immediate uproar owing to its pink colour and its almost total lack of windows. The latter was an extraordinary architectural omission, particularly given a waterfront position, which would have yielded some of the city's most fabulous views. Time has now tempered some of the initial criticism, and allowed the realisation to

Night-time illuminations add to the drama of the striking Hong Kong Cultural Centre

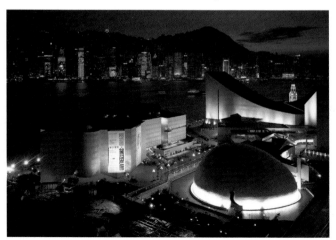

sink in that the building's magnificent modern interior serves its purpose well.

The centre contains three major performance venues – a 2,100-seat concert hall, 1,800-seat theatre and 300-seat theatre – as well as a library, cinema, garden and several restaurants. Be certain to wander to the rear (south) side of the building where a special walkway offers fine views of the harbour.

HONG KONG MUSEUM OF HISTORY ✪✪

Until recently the historical and cultural emphasis of much in Hong Kong has had a largely British bias. This appealing little museum has always bucked the trend, emphasising the history and culture of the indigenous peoples who have occupied the region over the centuries. In it the city's 6,000-year history is traced with a changing selection of exhibits from the museum's large archaeological and ethnographic collections. Highlights include the evocative 19th- and early 20th-century photographs of the city in its pre-high-rise heyday: look out in particular for photographs illustrating some of the catastrophic effects typhoons and landslips have had over the years.

Other eye-catching exhibits include neolithic tools and utensils, a model sampan, a collection of Chinese costumes and the interior of a typical early Hakka home (the Hakka were a northern Chinese people who migrated south and have lived and farmed on the Kowloon peninsula for centuries). Best of all is a full-scale reconstruction of a 19th-century Victoria street (Victoria was the name given to the modern-day Central district). In it you'll find a pawn shop, tea-house, opium den, print shop and a genuine medicine shop, the last lifted in its entirety from Wan Chai district during redevelopment.

🏠 70A2
✉ Kowloon Park, near Haiphong Road entrance
☎ 2367 1124
🕐 Tue–Sat 10–6, Sun, some holidays 1–6. Closed Mon, some holidays
🍴 Near by (£)
Ⓜ Tsim Sha Tsui
♿ Good
💷 Cheap
↔ Hong Kong Cultural Centre (➤ 72), Hong Kong Museum of Art (➤ 19), Hong Kong Space Museum (➤ 22), Kowloon Park (➤ 75), Nathan Road (➤ 76)
❓ Many of the museum's presentations are in Cantonese

Reconstructed traditional interiors are some of the highlights of the Hong Kong Museum of History

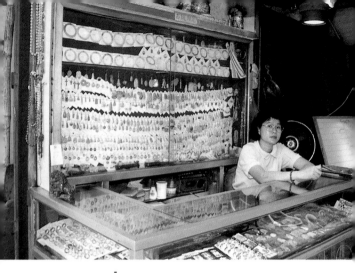

🕂 70A5

✉ Kansu Street, near the Gascoigne Road overpass

🕐 10–3:30. Stalls begin to close from 1PM

🍴 Near by (£)

🚇 Jordan or Yau Ma Tei

♿ Good

🎫 Free

↔ Temple Street Market (➤ 78)

Above: *buying jade is best left to the experts, but it can still be fun to browse among the stalls of the Jade Market*

🕂 70B2

✉ Corner of Nathan and Haiphong roads

☎ 2724 0095 to arrange a visit

🕐 Closed to the general public

🍴 Near by (£)

🚇 Tsim Sha Tsui

↔ Hong Kong Museum of History (➤ 73), Kowloon Park (➤ 75), Nathan Road (➤ 76)

JADE MARKET ✪

Hong Kong is one of the world's principal centres for the cutting and sale of precious and semi-precious stones, and of jade in particular. The Hong Kong branch of Christie's, the auctioneers, holds the world record sale price for a piece of jadeite jewellery – US$4.3 million for the Mdivani Necklace, sold in 1994. The city also holds the record for a publicly sold uncut diamond – £5.8 million for a 255.10-carat stone discovered in Guinea (1989).

At the more modest end of things is Hong Kong's Jade Market, slightly less interesting than its well-known reputation suggests. Most people come here just to look at the hundreds of stalls, and you should only buy if you really know what you are doing. The trade is aimed mainly at Chinese dealers (watch for the secret deals conducted in sign language), and while most stallholders are reasonably honest, a variety of scams are known to take place. Prices for visitors, in any case – unless you bargain hard – are usually higher than you'll find in malls and department stores.

KOWLOON MOSQUE ✪

Islam was introduced into China as early as the 7th century by Arab traders, so it comes as no surprise, given Hong Kong's multi-ethnic population, to find that the city has over 50,000 practising Muslims, around half of whom are Chinese. Many worship in the $30 million Kowloon Mosque, the city's largest, built in 1984 over an earlier mosque on the site. The latter was built in 1896 for the Muslim Indian troops stationed at nearby Whitfield Barracks (the present-day Kowloon Park). The mosque is appealing to look at from outside, with its minarets, marble dome and ornamented arches, but is closed to the non-Muslim general public. Visits can sometimes be arranged by appointment, though permission is not always granted.

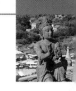

Did you know ?

A translucent green jade bracelet is traditionally bought by Chinese women to celebrate the birth of a son. Carved stones represent power (dragon), wealth (deer) and luck (tiger).

Below: the distinctive outlines of Hong Kong's largest mosque mark the entrance to Kowloon Park

KOWLOON PARK ★★★

Open space is to be prized in a city as crowded as Hong Kong, hence the popularity of Kowloon Park, which, though hemmed in by buildings and threatened by developers, offers a welcome respite from the crowds of Tsim Sha Tsui. Once it was the site of the Whitfield Barracks, home to British and Indian troops. Today it's a somewhat artificial creation, at least by the standards of most city parks, located above street level and entered via steps from Nathan Road and other street entrances. Open space jostles for attention with a sculpture garden, chess garden, children's playground, Chinese Garden (with fountains and lotus pond), an aviary of rare birds, sports hall and indoor swimming pool. The park is also home to the Hong Kong Museum of History (► 73) and close to the city's largest mosque (► 74), though the latter is closed to the non-Muslim general public.

- 70A3
- Off Nathan Road
- Daily 6AM–midnight. Aviary 7–7
- Near by (£–££)
- Tsim Sha Tsui
- Poor
- Free
- Hong Kong Museum of History (► 73), Nathan Road (► 76)
- 'Music in the Park' performances take place one Sunday afternoon a month between 2 and 5

pool opens 6:30 $9

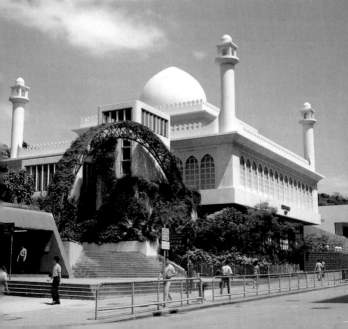

LEI CHENG UK MUSEUM ✪

This offshoot of the Hong Kong Museum of History is visited mainly for its 2,000-year-old Han Dynasty tomb, discovered in 1955 during work on a local housing estate. The tomb is Hong Kong's oldest human-made structure, built between AD 25 and 220, and consists of a domed central chamber and four brick- and barrel-roofed side chambers in the form of a cross. Once there would also have been a special entrance, but this was destroyed before workmen realised what they had found. Everything else has been preserved *in situ*, with the result that the five-minute walk here from the MTR station involves trekking through a rather grim area of industry and high-density housing.

The tomb is enclosed in concrete and sealed off for its own protection, so you can only glimpse its interior. The

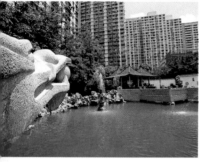

site revealed no human remains, only a variety of objects – now displayed in the museum – of the everyday articles the tomb's incumbents might have required in the afterlife: pots, pans, stove and a store of grain. Similar traditions continue to this day, only now it is paper models of cars, televisions and microwaves that are burned at funerals (▶ 58). The museum's modest displays are completed by photographs and diagrams of how the tomb might have appeared.

MUSEUM OF ART (▶ 19, TOP TEN)

NATHAN ROAD ✪

Nathan Road is a tumultuous street that cuts through the heart of Tsim Sha Tsui, running all the way from the waterfront to Boundary Street some 5km to the north (Boundary Street was the old border between Hong Kong and China before the New Territories were added to the former British colony in the 19th century).

Laid out in 1865, the street began life as Robinson Road, acquiring its current name from Sir Matthew Nathan, engineer and Governor of Hong Kong between 1904 and 1907. He had the road widened and extended, a pet project considered an unnecessary extravagance at the time – Kowloon was then only thinly populated – hence the road's nickname, 'Nathan's Folly'. Even in the 1950s the street had only one building higher than 10 storeys, and it remained something of an extravagance until the late 1960s, when commercial development in the area first took hold in earnest.

Today the road's hugely crowded southern reaches are known as the 'Golden Mile', after the high price of real

+ 81D3
✉ 41 Tonkin Street, Lei Cheng Uk Resettlement Estate, Sham Shui Po
☎ 2386 2863
🕐 Daily Tue–Sun 10–1, 2–6. Closed Mon, 25–26 Dec and the first three days of the Chinese New Year
🍴 Near by (£)
🚇 Cheung Sha Wan
🚌 Bus 2 from the Star Ferry Pier to Tonkin Street
♿ Good to museum displays, poor to tomb
🆓 Free

+ 80B3
🍴 Many cafés and restaurants (£–££)
🚇 Tsim Sha Tsui
♿ Poor: the street is very crowded
↔ Hong Kong Cultural Centre (▶ 72), Hong Kong Museum of Art (▶ 19), Hong Kong Museum of History (▶ 73), Hong Kong Space Museum (▶ 22), Kowloon Park (▶ 75)
❓ Beware of pickpockets and scams when shopping

Above: *the gardens surrounding the Lei Cheng Uk Museum*

estate and the sheer number of shops, restaurants and other businesses plying their trade amidst a forest of neon signs. Visitors should shop carefully, if at all, in many of the street's establishments, though it's well worth window-shopping or exploring the plethora of stores in the side streets near by. Streets of particular interest include Granville, Carnarvon, Cameron and Kimberley roads.

PENINSULA HOTEL ✪

Since it opened in 1928, the 'Pen' has been Hong Kong's hotel of choice among visiting royalty and VIPs. During its pre-war heyday it was one of several Far Eastern hotels whose names were synonymous with travel in the grand style. Distinguished guests once put up here after the long journey from London or Paris by rail and sea, part of an itinerary that might also have included the Taj Hotel in Bombay, the Strand in Yangon (Rangoon) and the famous Raffles in Singapore. A highly significant event occurred in 1941, when the hotel was the scene of Governor Sir Mark Young's official surrender of Hong Kong to the Japanese. It was then requisitioned for use by Japanese officers.

Other hotels may have stolen some of the Pen's thunder recently, but none can match its cachet or old-world style. Building work has added a tower to the landmark site, regaining some of the harbour views lost to land reclamation (the hotel once stood on the waterfront).

Even if you're not lucky enough to be staying here, you can still enjoy a drink in the magnificent lobby, where a string quartet will serenade you beneath the gold-corniced and colonnaded ceiling. Afternoon tea here is one of the city's great rituals. Alternatively, treat yourself to a meal in the Felix rooftop restaurant, renowned not only for its food, but also for its superb interior, the work of the celebrated French designer Philippe Starck.

🚩 70B2
✉ Salisbury Road, Tsim Sha Tsui
☎ 2366 6251
🕐 High tea in the lobby is served daily 3–6:30
🍴 Six restaurants (££–£££)
Ⓜ Tsim Sha Tsui
♿ Excellent
↔ Clock Tower (➤ 72), Hong Kong Cultural Centre (➤ 72), Hong Kong Museum of Art (➤ 19), Hong Kong Space Museum (➤ 22), Nathan Road (➤ 76)
❓ A dress code applies in the lobby for non-residents: no sandals, shorts or other 'inappropriate' dress are allowed

The 'Pen', Hong Kong's most famous hotel for more than 70 years

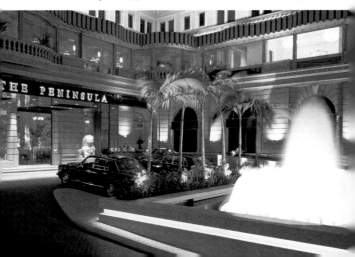

SPACE MUSEUM (► 22, TOP TEN)

STAR FERRY (► 24, TOP TEN)

TEMPLE STREET MARKET ⭐⭐

Few places in Hong Kong are livelier than Temple Street, heart of a market whose appeal is enhanced by the fact that it's at its busiest at night. The market's popularity with visitors has driven prices up, so the bargains are not what they were, though most of the food and other stalls are still aimed at locals rather than tourists. If you want to buy mainly clothes, shoes, leather, watches and everyday items then plump for the shops hidden in the streets behind the stalls rather than the stalls themselves.

The market livens up after about 8PM and continues in a frenzy of light, colour and crowds until around 11, though it and other markets in the parallel streets are also open during the day. There are fortune-tellers, street doctors, impromptu performances of Chinese opera and people playing mahjong (listen for the familiar clack of the counters). The famous Jade Market (► 74) is close by, but shuts earlier in the day, at around 3PM.

➕ 70A4
✉ Temple Street, Kansu Street and Reclamation Street
🕐 Daily 8AM–11PM
🍴 Food stalls and restaurants (£)
🚇 Jordan
♿ Good
🎟 Free
↔ Jade Market (► 74), Tin Hau Temple (► 79)
❓ Beware of pickpockets

Above: *signs on the fringes of Temple Street, site of a busy and bustling night-time market*

The promenade along Kowloon's waterfront offers superb views across the harbour

TIN HAU TEMPLE ✪

One of Kowloon's largest and oldest places of worship, the Tin Hau Temple is the temple after which the nearby Temple Street Market is named (► 78). It once looked over the sea and was dedicated to the goddess of seafarers, though land reclamation and development over the years means it now sits several blocks from the present-day waterfront.

Outside, people stand requesting alms or playing backgammon and mahjong. Inside, the temple is thick with throngs of worshippers and the scent of incense. Note the curved tile roofs, a feature designed to ward off evil spirits. The temple complex also houses shrines to Shing Wong (the god of the city), To Tei or Fook Tak (god of the earth) and Shea Tan (god of the local community).

You might want to take a chance with a *chim,* or fortune stick, a numbered stick which you shake with the others in a tube until one falls out. For a small fee a fortune-teller will plot your destiny based on your date of birth and the numerology of the stick.

🚻 70B5
✉ Market Street, one block north of Kansu Street
🕐 Daily 8–5:30 or 6
🍴 Near by (£)
Ⓜ Jordan
♿ Poor
🎫 Free
↔ Jade Market (► 74), Temple Street Market (► 78)

WATERFRONT PROMENADE ✪✪✪

Hong Kong's biggest attraction is the city itself, and often the best things about it are free. This is especially true of its views, and in particular those from the wide public walkway that hugs the Kowloon waterfront east of the Star Ferry Pier and Hong Kong Cultural Centre. You could, if you wished, follow this promenade as far as the Kowloon–Canton Railway Station, though views across the harbour to Hong Kong Island are outstanding from any point along its extensive length.

Come here to dodge the joggers, wonder at the fishermen – the harbour is famously polluted – and enjoy the constantly changing picture of yachts, tugs and a myriad other boats busying across the water. It's well worth taking this stroll at night to enjoy the spectacle of the city's lights glittering across the water. Note that you can catch a hoverferry to Central on Hong Kong Island from the Tsim Sha Tsui East Ferry Pier, located on the promenade alongside Kowloon's Shangri-La Hotel.

🚻 70C2
✉ Salisbury Road
🍴 Near by (£–£££)
Ⓜ Tsim Sha Tsui
♿ Excellent
🎫 Free
↔ Hong Kong Cultural Centre (► 72), Hong Kong Museum of Art (► 19), Hong Kong Science Museum (► 21), Hong Kong Space Museum (► 22)

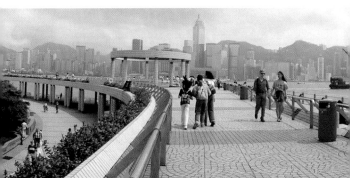

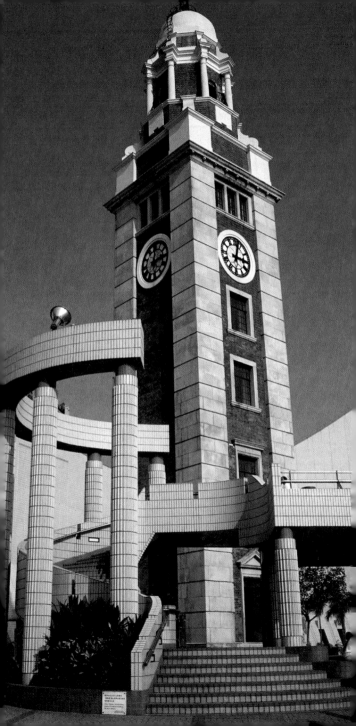

Through the Tsim Sha Tsui District

This walk introduces you to the key sights of Tsim Sha Tsui, the area at the southernmost tip of the Kowloon peninsula which contains many shops and malls and several of the city's key mid-range hotels.

Begin at the Star Ferry Pier. Turn left into the Ocean Centre if you wish to explore its labyrinth of shopping malls. Otherwise turn right and follow Salisbury Road as far as the left turn into Nathan Road.

Leaving the Star Ferry Pier you pass the site of the old Kowloon–Canton Railway Station, of which only the old clock tower survives. On the left side of Salisbury Road stands the Peninsula, one of Hong Kong's grandest and most venerable hotels. To the right stands the striking Hong Kong Cultural Centre. Nathan Road is one of the city's busiest and most famous shopping streets.

At the corner of Nathan Road and Haiphong Road turn left into Kowloon Park.

Note the Kowloon Mosque at the junction of Haiphong Road. Then explore Kowloon Park and visit the excellent Hong Kong Museum of History.

Exit the park on Nathan Road and walk south until you come to Granville Road. Turn left and follow Granville Road to Chatham Road. Climb the raised walkway across the road and bear left following signs to the Hong Kong Science Museum. Visit the museum and then walk south on Science Museum Road. At its southern end turn right on to the pedestrianised Waterfront Promenade.

The Science Museum is one of Hong Kong's most compelling museums, while the Waterfront Promenade offers superb views of the Hong Kong skyline.

Opposite: *all that remains of the Kowloon to Canton railway*
Above: *bright lights of Nathan Road, premier shopping street*

Distance
3.4km

Time
Allow up to a day depending on sights visited

Start/end point
Star Ferry Pier
🚌 70A1
Ⓜ Tsim Sha Tsui
🚍 Star Ferry Bus Terminal
⛴ Star Ferry

Lunch
Picnic in Kowloon Park or visit a café or fast-food outlet: try Oliver's in Granville Road, or the snack bar at the Science Museum

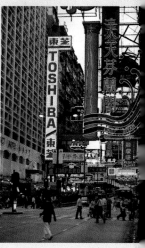

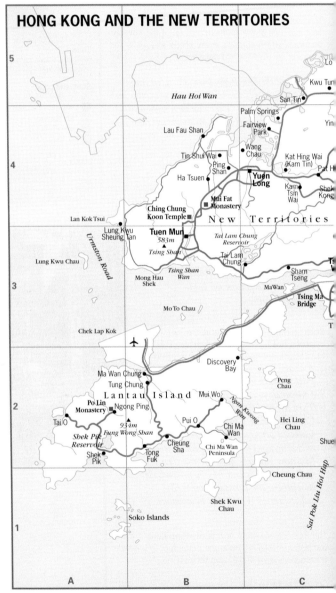

HONG KONG AND THE NEW TERRITORIES

Hau Hoi Wan

Lo

Kwu Tun

San Tin

Palm Springs

Fairview Park

Yin

Lau Fau Shan

Wang Chau

Tin Shui Wai

Ping Shan

Kat Hing Wai (Kam Tin)

Pat H

Ha Tsuen

Yuen Long

Mui Fat Monastery ■

Kam Tsin Wai

Shek Kong

Ching Chung Koon Temple ■

New Territories

Lan Kok Tsui

Lung Kwu Sheung Tan

Tuen Mun
583m
Tsing Shan

Tai Lam Chung Reservoir

Urmston Road

Tai Lam Chung

T

Lung Kwu Chau

Tsing Shan Wan

Sham Tseng

Mong Hau Shek

MaWan

Tsing Ma Bridge

Mo To Chau

T

Chek Lap Kok

✈

Discovery Bay

Peng Chau

Ma Wan Chung

Tung Chung

Lantau Island

Mui Wo

Ngong Kwong Wan

Po Lin Monastery ■ Ngong Ping

Pui O

Chi Ma Wan

Hei Ling Chau

Tai O

934m
Fung Wong Shan

Cheung Sha

Chi Ma Wan Peninsula

Shue

Shek Pik Reservoir

Shek Pik

Tong Fuk

Cheung Chau

Sai Pok Liu Hoi Hap

Shek Kwu Chau

Soko Islands

A B C

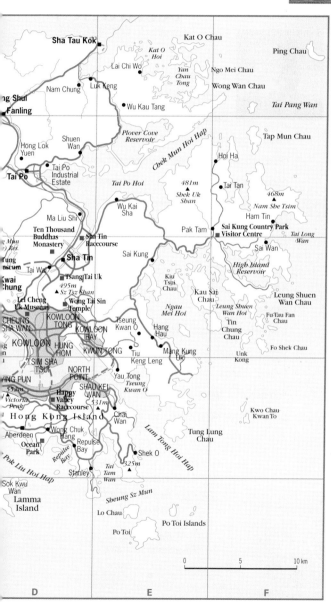

Sha Tau Kok

Kat O Chau

Kat O Hoi

Ping Chau

Lai Chi Wo

Yan Chau Tong

Ngo Mei Chau

Nam Chung

Luk Keng

Wong Wan Chau

ng Shui

Wu Kau Tang

Tai Pang Wan

Fanling

Plover Cove Reservoir

Chek Mun Hoi Hap

Tap Mun Chau

Hong Lok Yuen

Shuen Wan

Hoi Ha

Tai Po Industrial Estate

Tai Po

Tai Po Hoi

481m
Shek Uk Shan

Tai Tan

468m
Nam She Tsim

Ma Liu Shui

Wu Kai Sha

Ham Tin

Ten Thousand Buddhas Monastery

Sha Tin Racecourse

Pak Tam

Sai Kung Country Park Visitor Centre

Tai Long Wan

g Mun
) Res.

Sha Tin

Sai Kung

Sai Wan

Tung
useum

Tai Wai

High Island Reservoir

wai
hung

Tsang Tai Uk

495m
Sz Tsz Shan

Kiu Tsui Chau

Kau Sai Chau

Leung Shuen Wan Chau

Lei Cheng
Uk Museum

Wong Tai Sin Temple

Ngau Mei Hoi

Leung Shuen Wan Hoi

Fu Tau Fan Chau

CHEUNG
SHA WAN

KOWLOON TONG

Tseung Kwan O

Tin Chung Chau

KOWLOON
BAY

Hang Hau

KOWLOON

HUNG HOM

KWUN TONG

Tiu Keng Leng

Mang Kung Uk

Unk Kong

Fo Shek Chau

TSIM SHA TSUI

Yau Tong

Tseung Kwan O

NG PUN

NORTH POINT

SHAU KEI WAN

552m
Victoria Peak

Happy Valley Racecourse

531m

Kwo Chau Kwan To

Hong Kong Island

Chai Wan

Aberdeen

Wong Chuk Hang

Tung Lung Chau

Ocean Park

Repulse Bay

Lam Tong Hoi Hap

Pok Liu Hoi Hap

Repulse Bay

Shek O

Stanley

325m

Tai Tam Wan

Sok Kwu Wan

Sheung Sz Mun

Lamma Island

Lo Chau

Po Toi Islands

Po Toi

0 5 10 km

D E F

The New Territories

Between Kowloon and what used to be the border with China lie the New Territories, so called because they were the last concession made to Britain at the end of the 19th century. The region is a chequerboard of booming new towns, traditional villages and pockets of largely unspoilt countryside and coastline. It is well worth seeing something of the area, if only on one of the HKTA's two tours, an excellent way of exploring the region if you are short of time. Accessible retreats can be enjoyed on some of the many islands that scatter the seas around Hong Kong. A visit to Cheung Chau, Lantau or Lamma, three of the closest (all an hour or less away by boat), offers startling contrasts to Kowloon and Hong Kong Island, transporting you from a labyrinth of concrete and high-rise to a world of old fishing villages, small farming communities, ancient temples and peaceful countryside. Regular, cheap ferries depart from piers on Hong Kong Island near the Star Ferry terminal.

> *'All Hong-Kong is built on the sea-face; the rest is fog. One muddy road runs for ever in front of a line of houses...'*

Rudyard Kipling,
From Sea to Sea (1889)

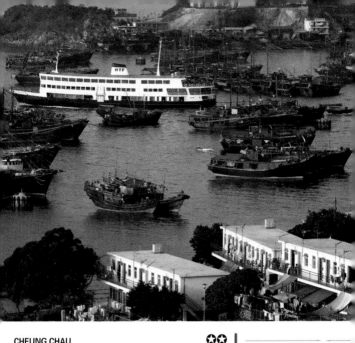

CHEUNG CHAU ✪✪

Cheung Chau (Long Island) lies 24km southwest of Hong Kong and covers just 2.4sq km. It is far from empty – some 40,000 people live here – but a network of surfaced paths (there are no cars) allows you to explore the hills above the handful of streets that make up Cheung Chau village. In the village be sure to drop into the local market and to visit the Pak Tai Temple (1783), dedicated to the 'Supreme Emperor of the Dark Heaven'. Walks around the headland to the north offer lovely views over the island. Also visit the island's two popular beaches, Tung Wan and Kwun Wan, and scramble to the Cheung Po Tsai Cave, reputed hideout of a notorious 19th-century pirate.

LAMMA ✪✪

Lamma is not the prettiest of Hong Kong's islands, but is one of the largest and one of the closest to the city (45 minutes by ferry). Boats dock at the two main villages, Yung Shue Wan to the northwest or Sok Kwu Wan to the southeast. Your best plan of attack is to land at Yung Shue Wan, stroll around the village, and then take the surfaced path which winds up into the hills and down to Sok Kwu Wan (the path is easily found: simply follow the village's main street and take the first major turn left). This is a popular walk, especially at weekends (allow a couple of hours), and offers some pretty snatches of countryside – spoiled only by a large power station – and the chance to eat outdoors in one of Sok Kwu Wan's waterfront restaurants. To pick a restaurant simply look for one that's full of locals. Ferries return to Hong Kong from the adjacent pier.

🚩 80C1
🚢 Daily ferries for Cheung Chau leave hourly from Ferry Pier 7 in Central. Journey time is one hour: faster hoverferries run Mon–Fri
🍴 Bars, cafés and restaurants (£–££) in Cheung Chau Village
❓ Pick up the informative *Cheung Chau Walking Tour* booklet from the HKTA offices

🚩 81D1
🚢 Daily ferries from Ferry Pier 6 in Central. Daily *kaido* (motorised sampan) service from Aberdeen
🍴 Bars, cafés and restaurants (£–££) at Yung Shue Wan and Sok Kwu Wan
❓ Bicycles can be rented at Yung Shue Wan just off Main Street en route for Hung Shing Yeh beach

Above: *There are plenty of boats but no cars on Cheung Chau Island*

Walking is the best way to enjoy the beauty of Lantau

LANTAU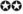

Lantau is the largest of Hong Kong's islands – twice the size of Hong Kong Island – and by far the most beautiful. It boasts spectacular mountains, verdant valleys, tranquil monasteries, a series of old Chinese forts, two country parks and plenty of marked hiking trails, picnic places and campsites. Allow a day here, as most of the key sights are some way from Mui Wo (Silvermine Bay), the main ferry terminus. Here you can pick up a bus or taxi to Po Lin Monastery, the island's most popular attraction, an important Buddhist shrine set amidst lovely countryside on Lantau Peak (750m). Founded in 1905, the monastery was used as a modest retreat until 1928 when it was expanded to become one of Hong Kong's largest monasteries. Several new temples were created in 1970, and it was opened to the public. Opposite stands one of the world's largest statues of Buddha. Also visit Tai O, a quaint village known as 'Little Venice' – many of its houses are built on stilts – and Cheung Sha and Pui O, two of Hong Kong's finest beaches.

SAI KUNG

Not so long ago much of the New Territories was a largely pastoral vision of small farms, bucolic countryside and pretty coastline. These days urbanisation continues apace, nibbling away at the green space and compromising the region's countryside. Pristine landscapes still exist, however – you'll glimpse many as you journey through the region – but for a taste of some of the best you should head for the beautiful and largely unspoiled region around Sai Kung. Embracing much of the New Territories' eastern seaboard, the region is one of Hong Kong's wildest,

fringed by sandy bays and dotted with protected country parks. One of the most pleasant ways to see the coast is to rent a *kaido*, a small private boat, in the town of Sai Kung, where you might also eat in one of the local fish restaurants (though it's safer to avoid the seafood). Or you could enjoy sea and mountain views by walking the first section (10.6km) of the MacLehose Trail in the Sai Kung Country Park, located about 15 minutes away by bus or taxi from Sai Kung. If all this seems too strenuous inquire at the park visitor centre (near the park bus terminal at Pak Tam Chung) for details of the 30-minute Pak Tam Chung Nature Trail.

Around 20 minutes' walk from the visitor centre is the **Sheung Yiu Folk Museum** (follow the signposted route), which is largely based around a restored terrace of 150-year-old houses. This little museum is filled with an interesting array of displays illustrating various facets of traditional village life.

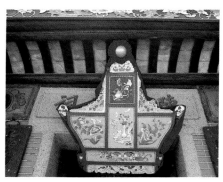

SAM TUNG UK MUSEUM ✪✪

Visitors with little time and wanting a taste of the New Territories would be well advised to take a HKTA tour. Those prepared to explore just one area on their own might make for Tsuen Wan ('Shallow Bay'), a typical high-rise new town which is home to an excellent folk museum. Located about 300m from the Tsuen Wan MTR station, the museum occupies a landscaped and slightly over-restored walled village dating from 1786. It consists of a number of individual village houses, each decorated in period style and designed to illustrate a particular aspect of traditional village life, including furniture-making, farming, festivals, handicrafts and ritual ceremonies.

You might also visit Chuk Lam Shim Yuen ('Bamboo Forest Monastery'), one of Hong Kong's most impressive Buddhist monasteries. Founded in 1927, it has three of the city's largest statues of Lord Buddha and draws hundreds of daily worshippers. The monastery lies just 20 minutes' walk or a short taxi ride from Tsuen Wan MTR station.

🍴 Several Western-style pubs and restaurants and local restaurants in Sai Kung and elsewhere (£–££)

🚇 MTR to Choi Hung (Ngau Chi Wan Civic Centre exit), then the 92 bus. From Sai Kung take the 94 Wong Shek Pier bus to Pak Tam Chung and the Sai Kung Country Park Visitor Centre, a scenic 15-minute ride.

♿ Poor

Sheung Yiu Folk Museum
☎ 2792 7365
🕐 Wed–Mon 9–4

Detail of a beautifully restored 18th-century village house in the Sam Tung Uk Museum

➕ 81D3
✉ Kwu Uk Lane: turn left outside the MTR station and follow signs along the pedestrian walkway
☎ 2411 2001
🕐 Wed–Mon 9–5. Closed Tue, some public holidays
🍴 Near by (£–££)
🚇 MTR to Tsuen Wan
♿ Good
🎫 Free

✚ 81D3

🍴 Many restaurants and fast-food outlets, especially in the New Town Plaza (£–££)

🚃 KCR from Kowloon KCR Station to Sha Tin station

❓ The HKTA *Official Sightseeing Guide* provides useful street maps of Sha Tin and other areas of the New Territories

Ten Thousand Buddhas Monastery

✉ Po Fook Hill

🕐 Daily 9–5

✋ Free

One of the vast number of statues that adorn the Ten Thousand Buddhas Monastery

SHA TIN ⬤⬤

Located just 11km north of Tsim Sha Tsui, Sha Tin and its surrounding attractions are some of the most-easily visited areas of the New Territories. Simply jump aboard the Kowloon–Canton Railway (KCR) line and get off at Sha Tin station. The main sights here include several temples, a traditional walled village, pretty mountain trails and the second of Hong Kong's horse-racing tracks.

Once a predominantly agricultural region – its name in Chinese means 'sandy field' – Sha Tin is now almost entirely urban, its population around 700,000 and rising. Almost immediately opposite the station lies the New Town Plaza, a vast shopping and entertainment complex that teems with people and provides a graphic insight into how daily life is lived in much of the New Territories. The big draw here, apart from the shops and restaurants, is the central fountain, which periodically erupts in a display of lights, water sprays and other special effects.

A few minutes' walk north of the station lies the **Ten Thousand Buddhas Monastery** (Man Fat Tze), the region's major attraction. Built in 1950, the monastery is reached through landscaped gardens via either escalators or some 400 steps. The main monastery contains three large statues of Lord Buddha and around 12,800 smaller

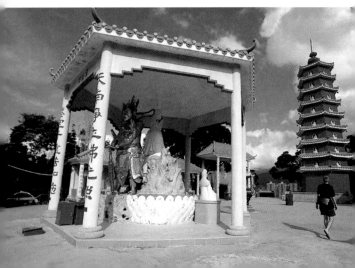

The pagoda at the Ten Thousand Buddhas Monastery offers lovely views over the New Territories

statuettes, each depicting Lord Buddha in a slightly different pose. Several smaller temples complete the monastery complex, including one which contains the gilded and preserved body of Yuet Kai, the founding monk, who died in 1965. Outstanding views over Sha Tin are available from the temple terraces and adjacent pagoda: try to pick out the Amah Rock across the Sha Tin Valley, which legend claims is a young wife and her baby turned to stone by the gods.

Walk or take a taxi about a kilometre south of the KCR station and you come to **Tsang Tai Uk** (literally 'Tsang's Big House'), a well-preserved 19th-century fortified village built by the Tsang clan, a handful of whose descendants live here to this day. Typical of traditional villages found across Guangdong (Canton) province, Tsang Tai Uk consists of four rows and two side columns of houses built around a central courtyard, with watch towers standing guard at its four corners.

Take a taxi or the KCR line one station south to Tai Wai and you can visit the Taoist Che Kung Temple, dedicated to a Song Dynasty (960–1279) general who suppressed a revolt in southern China and was later deified. Travel a couple of stations the other way, to the Racecourse Station, and you can visit the 85,000 capacity **Sha Tin Racecourse**, one of the world's most modern and sophisticated racetracks (▶ 48–9 for details of the Happy Valley track). Call 2807 6390 for details of race meetings, or to join the HKTA Come Horseracing guided tour.

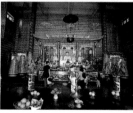

Tsang Tai Uk
☒ Sha Kok Street, off Tai Chung Kiu Road
✋ Free

Sha Tin Racecourse
☒ Tolo Highway
🕐 Meetings are usually held on Sat or Sun afternoons and Wed evenings between Sep and Jun
✋ Free

WONG TAI SIN TEMPLE ✪✪✪

81D3
Wong Tai Sin Estate
2801 1777 or 2327 8141
Temple: daily 7–5:30.
Good Wish Garden:
Tue–Sun 9–4
Near by (£)
Wong Tai Sin MTR
Good
Temple: small donation.
Good Wish Garden:
cheap. Nine Dragon Wall
Garden: small donation
It is not always possible
to gain access to the
temple's inner sanctum

Huge, brash and colourfully decorated, the Wong Tai Sin temple was built in 1973 in honour of the eponymous god, a shepherd taken by an immortal as a young boy and taught how to devise an elixir of immortality. Today he is one of Hong Kong's most popular gods and the temple one of the city's most revered Taoist shrines. The image of the god on the temple's high altar was brought from mainland China in 1915 and installed in a temple in Wan Chai on Hong Kong Island. It was moved to an earlier temple on the present site six years later.

Before you reach the temple entrance you pass a street arcade crammed with fortune-tellers, palm readers, soothsayers and even physiognomists, who feel the bumps on your head. Lion Rock, a fine Hong Kong landmark, can be glimpsed from an open area just off the arcade.

The temple itself is built to embrace the five geomantic elements of fire, earth, gold, wood and water. Fire and earth are represented in the Yue Heung Shrine, water in the temple fountain, wood in the Library Hall and gold in the Bronze Luen Pavilion. Devotees of Confucius are able to pay their respects in the Confucius Hall, while in the Three Saints Hall Buddhists are able to worship Kuan Yin, the Buddhist goddess of mercy, and Kwan Ti and the eight immortals. The rear of the temple compound contains two attractive Chinese gardens: the Good Wish Garden, a miniature copy of Beijing's Summer Palace and the Nine Dragon Wall garden, inspired by a renowned mural in Beijing's Beihai Park.

Worshippers at the Wong Tai Sin Temple

Sunday here is very busy, although the area is thick with stalls and people selling lucky cards, windmills, paper (or 'hell') money, incense and joss sticks most of the time. People bring offerings of food or buy oranges from local stalls; the popularity of oranges as a votive explains why Hong Kong is the world's largest consumer of the fruit. The temple is especially busy over Chinese lunar New Year in January, when good luck is at a premium, the seventh lunar month (the so-called 'ghost' month) and on Wong Ta Sin's birthday (the 23rd day of the eighth lunar month – usually in September).

YUEN LONG ✪

80C4
Restaurants (£)
68M or 68X from Jordan
Road ferry pier
Hovercraft from Ferry
Pier 5 in Central to Tuen
Mun, then LTR
Poor
Kat Hing Wai: donation;
also to photograph Hakka
women in costume

This is not a town to visit for its own sake, but as the jumping-off point for several more interesting sights. Most are traditional buildings or old walled villages, many of which feature on HKTA tours. Lau Fau Shan, a ramshackle and atmospheric village 4km northwest, is known for its fish restaurants and oyster beds: but take care with the seafood, as pollution here is a problem. The best-known walled village is 400-year-old Kat Hing Wai (or Kam Tin), though it is perhaps a little too tourist-orientated, unlike the villages of Ha Tsuen and Ping Shan on the coast.

Where To...

Above: oranges
are very popular
in Hong Kong
Right: a market
sweetcorn seller

Hong Kong Island

How Much Will it Cost?

The price brackets used here are for the equivalent of a three-course meal for one without drinks or service:

(£)	**= HK$50**
(££)	**= HK$150–300**
(£££)	**= over HK$300**

Dim Sum

Dim sum, literally 'small heart' or 'to touch the heart', is one of the mainstays of Cantonese cooking, Hong Kong's most widespread regional Chinese cuisine. A form of daytime snack, it features over 2,000 different dishes, though most Hong Kong *dim sum* restaurants – of which the city has many hundreds – offer around 150. *Dim sum* is usually served from early morning to late afternoon. Lunch and Sundays are the busiest times. Restaurants are usually large and brightly decorated, often in red or gold, colours chosen for their lucky associations. They are also usually fairly lively – *dim sum* is meant to be a noisy and enjoyable occasion. At your table you are brought either jasmine tea or the strong black Chinese *bo lay*. These days you usually order from a menu, but in more traditional places you can still choose from food paraded on trolleys. Food is generally served in steaming bamboo baskets and you are charged per dish. Prices are usually very reasonable.

Bentley's Seafood Restaurant & Oyster Bar (££)

A traditional British club-like restaurant where first-class European cooking is mixed with the occasional southeast Asian dish.

✉ B4, Basement, Prince's Building, 3 Des Voeux Road, Central ☎ 2868 0881 🕔 Mon–Sat 11–10.30. Closed Sun 🚇 Central

Chiu Chow Garden (£–££)

The restaurants in the small Chiu Chow chain are good places to sample a variety of Chinese cooking little known in the West. Roast goose is one of the chain's specialities.

✉ Basement, Jardine House, 1 Connaught Place, Central ☎ 2525 8246 🕔 Daily 11–3, 5:30–12 🚇 Central
✉ 3rd Floor, Vicwood Plaza, 199 Des Voeux Road, Central ☎ 2545 7778 🕔 Daily 10–3, 5:30–12 🚇 Central

Cinta (££)

Offers Asian dishes, ranging from Filipino and Malaysian specialities such as *pata* (pork) to Indonesian staples such as *satay*, squid and chilli prawns, in a pleasant and relaxed atmosphere. The slightly cheaper Cinta-J is just around the corner.

✉ 1st & 2nd Floor, Shing Yip Building, 10 Fenwick Street, Wan Chai ☎ 2527 1199 🕔 Daily 11AM–2AM 🚇 Wan Chai
✉ Cinta-J, Shop G-4, Malaysia Building, 69–75 Jaffe Road, Wan Chai ☎ 2529 6622 🕔 Daily 11AM–4AM 🚇 Wan Chai

Dan Ryan's Chicago Grill (££)

Two great bars and grills serving top quality North American staples – in vast quantities. Leave room for the belt-loosening desserts. Both outlets (➤ 96) are often busy; be sure to book.

✉ 114 Pacific Place, 88 Queensway, Central ☎ 2845 4600 🕔 Mon–Thu 11–12; Fri 11AM–2AM; Sat 10AM–2AM; Sun 10AM–midnight 🚇 Admiralty

Diamond Restaurant (£)

A large, busy, no-nonsense Cantonese restaurant. The best time to come is for *dim sum*, served in a boisterous and genuinely Chinese atmosphere. Just point if you don't know the names of dishes.

✉ 267–275 Des Voeux Road, Central ☎ 2544 4921 🕔 Daily 6:30AM–11:30PM; *dim sum* 6:30–4 🚇 Sheung Wan

Fook Lam Moon (£££)

For a top Cantonese restaurant it's hard to choose between Man Wah, One Harbour Road or the two Fook Lam Moon outlets. Over the years the Fook has been one of the city's best-known and most consistently reliable establishments.

✉ 35–45 Johnston Road, Wan Chai ☎ 2866 0663 🕔 Daily 11:30–11:30; *dim sum* 11:30–3 🚇 Wan Chai

House of Canton (££)

One of three restaurants in the House of Canton chain. The ambience is pleasantly up-market and the conventional Cantonese dishes are often enlivened with innovative culinary twists.

✉ Shop 101–103 Caroline Centre, 2–38 Yun Ping Road, Causeway Bay, ☎ 2882 1383 🕔 Mon–Sat 11–11, Sun 10–5; *dim sum* Mon–Sat 11–5, Sun 10–5 🚇 Causeway Bay

Hunan Garden (££–£££)

Food from the Hunan region is almost as hot and spicy as Szechuan cuisine. But not all dishes are fiery: safe choices include glazed hams, duck, rich noodle soups, mashed chicken soup, dumplings and lily or lotus desserts.

✉ The Forum, Exchange Square, 8 Connaught Place, Central ☎ 2868 2880 🕐 Daily 11:30–3, 5:30–12 🚇 Central

Indochine 1929 (£££)

First choice for Vietnamese food, albeit at high prices. There are big potted plants and period photos, and the food marries traditional Vietnamese cuisine and ideas from the west.

✉ 30–32 D'Aguilar Street, Lan Kwai Fong, Central ☎ 2869 7399 🕐 Mon–Thu 12–2:30, 6:30–10:30; Fri–Sat 12–2:30, 6:30–11; Sun, public holidays 6:30–10:30 🚇 Central

Jimmy's Kitchen (££)

One of Hong Kong's most famous restaurants, but a little overpriced and rather trading on its reputation. Relaxed, traditional and comfortable setting, with booths and lattice screens, and reliable dishes such as goulash and stroganoff.

✉ Basement, South China Building, 1 Wyndham Street, Central ☎ 2526 5293 🕐 Daily 12–12 🚇 Central

Jumbo Palace Floating Restaurant (£££)

Take a ferry to this famous but overpriced and rather touristy institution, located on a brightly decorated boat whose palace-like interior is an attraction in itself. There are two sister ships near by: the Jumbo Palace and the more intimate Tai Pak.

✉ Shun Wan, Wong Chuk Hang, Aberdeen ☎ 2553 9111 🕐 Daily 7AM–11PM; dim sum 7–5 🚌 7, 70

Kanetanaka (£££)

High prices have made little impact on the popularity of this long-established Japanese restaurant, a place that appeals to residents and Japanese visitors alike.

✉ 22nd Floor, East Point Centre, 545–563 Hennessy Road, Causeway Bay ☎ 2833 6018 🕐 Daily 12–3, 6:30–11 🚇 Causeway Bay

Luk Yu Tea House & Restaurant (££)

A visit to this venerable and highly authentic Cantonese institution is essential to any visit to the city. It looks, sounds and feels like the real thing – all wood panels, brass spittoons, black fans and Chinese screens – so be prepared for the noise, bustle, brusque service and a wait for a table: they're all part of the experience.

✉ 24–26 Stanley Street, Central ☎ 2523 5464 🕐 7AM–10PM; dim sum 7–6 🚇 Central

Man Wah (£££)

First choice for an expensive treat, the Mandarin Oriental hotel connection guarantees quality: excellent food, outstanding views in an elegant and intimate setting. The bill, though, is huge.

✉ Mandarin Oriental Hotel, 5 Connaught Road, Central ☎ 2522 0111 🕐 Daily 12–3, 6:30–11 🚇 Central ❓ Reservations essential

Mozart Stub'n (££–£££)

The name means 'farmhouse kitchen': more or less the look and feel of this excellent Austrian and Central European-inspired restaurant. You will need to take a taxi or climb the hill on foot, but the food is worth the haul.

✉ Ground Floor, 8 Glenealy, Central ☎ 2522 1763 🕐 Mon–Sat 12–3, 6:30–12 🚇 Central ❓ Reservations essential

Restaurant Tips

In larger Chinese restaurants you will be met and seated by a hostess. Tea (often free) will usually be brought after you sit down. Service may appear abrupt to Western eyes, and some staff may be genuinely rude, but generally it is a matter of different culture, different approach: don't be intimidated. Menus often have English translations, but sometimes not all available dishes will be listed in translation: seasonal specialities, for example, are usually only in Chinese. If in doubt, point. Check the price of seasonal and other specialities carefully: they are usually expensive. When food arrives help yourself from the communally presented dishes. Request a fork if chopsticks are too difficult. Porcelain spoons are provided for soups. Never leave chopsticks sticking up in food – this symbolises a funeral boat and death and is considered unlucky. The bill is mai dan: otherwise simply gesture. Even where service is included it is usual to leave any small change as an extra tip. Otherwise tip 10 per cent.

American Classics

Hong Kong is liberally scattered with McDonalds, KFC, Burger King, Pizza Hut and other American and American-style fast-food outlets. Maxim's is another good chain that sells cakes and pastries as well as fast-food staples. The most famous of the North American classic names, however, are the more up-market and popular Planet Hollywood and the two outlets of the Hard Rock Café.

Mughal Restaurant (££)

Many Indian restaurants here are cheap but have little else to recommend them: some are downright health risks. Not the Mughal, which offers a charming atmosphere and reliable, high-quality food.

✉ Carfield Building, 75–7 Wyndham Street, Central ☎ 2524 0107 🕔 Sun–Thu 12–3, 6–11:15; Fri–Sat 12–3, 6–11:45 🚇 Central

One Harbour Road (£££)

Cooking of the highest quality, and a favourite with business executives and visitors enjoying a treat. A glass roof and intriguing split-level, mock art-deco interior add to its pleasures.

✉ Grand Hyatt Hotel, 1 Harbour Road, Wan Chai ☎ 2588 1234 ext 7338 🕔 Daily 12–2:30, 6:30–10:30 🚇 Wan Chai ❓ Reservations essential

Peak Café (££–£££)

While visiting the Peak you could do a lot worse than enjoy the wonderful sea views and the American west coast-style food at this restaurant. The cooking is a blend of Asian and New World. Try for tables on the terrace with sea views.

✉ 121 Peak Road, The Peak ☎ 2849 7868 🕔 Mon–Fri 10:30–11:30; Sat–Sun 8AM–11:30PM 🚇 Peak Tram ❓ Reservations essential for terrace tables

Peking Garden (££)

The three central outlets in this first-rate chain are perfect places to sample the more robust cuisine associated with northern China. Noodle-making and Peking duck-carving are often laid on as side shows.

✉ Alexandra House, 6 Ice House Street, Central ☎ 2526 6456 🕔 Daily 11:30–3, 5:30–12 🚇 Central

✉ Hennessy Centre, 500 Hennessy Road, Causeway Bay ☎ 2577 7231 🚇 ✉ Shop 003, The Mall, Pacific Place, 88 Queensway, Central ☎ 2845 8452

Post 97 (£–££)

Far more than the trendy café and nightspot it first appears, for the innovative and eclectic mixture of North American and Mediterranean brasserie food – as well as snacks and sandwiches – is excellent.

✉ Cosmos Building, 9–11 Lan Kwai Fong, Central ☎ 2810 9333 🕔 Mon–Thu 9AM–2AM; Sat–Sun all day 🚇 Central

The Red Pepper (££)

Spicy, mouth-searing Szechuan food, as the name suggests, is the staple of this popular family-run restaurant, in business over 20 years.

✉ 7 Lan Fong Road, Causeway Bay ☎ 2577 3811 🕔 Daily 12–11:45 🚇 Causeway Bay

Shanghai Garden (££)

The best bet on Hong Kong Island for Shanghai cuisine, this is more elegant and expensive than most of Hong Kong's Chinese restaurants, though prices are still good by Central standards and the delicious food is worth paying well for.

✉ 115–24/126 Hutchison House, 10 Harcourt Road, Central ☎ 2524 8181 🕔 Daily 11:30–3, 5:30–12 🚇 Central

Stanley's French Restaurant (££–£££)

First choice for eating in Stanley, the modern Provençal-style menu specialises in mouthwatering seafood, but other French staples also feature. Ask for terrace or roof tables overlooking the bay.

✉ 86 Stanley Main Street, Stanley ☎ 2813 8873 🕔 Daily 9AM–midnight 🚌 6, 260 ❓ Reservations essential

Stanley's Oriental (££–£££)
Here East meets West, with culinary influences ranging from Creole and Cajun to Indian, Thai and Japanese. The waterfront location is a pleasant bonus: try for a table on the upper level or fan-cooled verandas for a romantic meal.

✉ 90B Stanley Main Street, Stanley ☎ 2813 9988
🕐 Daily 9AM–midnight
🚌 6, 6A, 6X, 260, 63

Supatra's (££)
One of the city's best Thai restaurants, conveniently located at the heart of Central's trendy Lan Kwai Fong nightlife district. Drink in the bar downstairs before moving to the more formal dining area upstairs.

✉ Ground Floor, 50 D'Aguilar Street, Lan Kwai Fong, Central
☎ 2522 5073 🕐 Daily 12–12, later at weekends 🚇 Central

Sze Chuen Lau (££)
A comfortable, old-fashioned and long-established restaurant. The atmosphere is cheerful, the prices reasonable and the service brisk, though waiters are used to foreigners. Popular with locals and visitors, so arrive early or book. Food is the cuisine of Szechuan.

✉ 466 Lockhart Road, Causeway Bay ☎ 2891 9027
🕐 Daily 12–12 🚇 Causeway Bay

Tables 88 (££–£££)
One of the trendier places, thanks largely to an eye-catching avant-garde interior which has been installed in the old 19th-century Stanley police station. Offers an extensive menu of mostly Mediterranean-type dishes.

✉ 88 Stanley Village Road, Stanley ☎ 2813 6262
🕐 Daily 11:30–10:30; bar open until 1AM 🚌 6, 260
❓ Bar open for drinks without meals

Tandoor (££)
The place to come if you want to eat Indian food in more elegant surroundings than you find in most of Hong Kong's Indian restaurants. Has live Indian music in the evenings.

✉ 3rd Floor, On Hing Building, 1–9 On Hing Terrace, Central
☎ 2845 2299 🕐 Daily 12–2:30, 6–11 🚇 Central

Va Bene (£££)
Innovative Venetian and north Italian cooking is matched by a sleek modern interior and attentive service at this fashionable restaurant, though many consider it vastly overrated.

✉ 58–62 D'Aguilar Street, Central ☎ 2845 5577 🕐 Mon–Fri 12–2:30, 7–10:30 🚇 Central

Yung Kee (££)
Restaurants do not come much bigger – four floors and seats for many hundreds – though the size spoils neither food nor service. Popular with a wide range of customers, this was among former Governor Patten's favourite restaurants and is the only one in the city to make *Fortune* magazine's top 15 restaurants worldwide listing. An essential choice.

✉ 32–40 Wellington Street, Central ☎ 2522 1624
🕐 Daily 11–11:30; *dim sum* Mon–Sat 2–5:30, Sun 11–5 🚇 Central

Zen (£££)
A modern and up-market restaurant. Highly polished designer interior with sleek service and refined contemporary Cantonese cooking.

✉ LG1, The Mall, Pacific Place One, 88 Queensway, Central
☎ 2845 4555 🕐 Mon–Fri 11:30–3:30, 6–11; Sat 11:30–4:30, 6–11; Sun 10:30–3:30, 6–11. *dim sum*: same as daily lunch hours 🚇 Central

Meals
Chinese meals usually start with a cold meat dish followed by fish or seafood, red or white meat, vegetables and soup. White rice is the usual accompaniment, though bread noodles can replace rice, especially in northern-style (Peking) restaurants. When ordering the general rule is to order one dish per person, plus one extra (usually a soup). Traditionally a meal should combine the five basic tastes of Chinese cooking: hot, bitter, acid, sweet and salty, thus maintaining the delicate balance between the positive (*yang*) and negative (*ying*). Textures should balance crisp and tender, dry and sauced. Such tenets were established centuries ago, and many younger Chinese view them as little more than superstition, though they are still frequently adhered to.

Kowloon

What to Drink

Tea is a common accompaniment to most Chinese and other Asian cuisines. It is drunk without milk, sugar or lemon. Beer is also widely drunk: the best Chinese beer is Tsingtao, made to a German recipe, though locally brewed San Miguel and Carlsberg are also popular. Wine, especially fine French claret, is becoming increasingly coveted, thanks largely to its price and prestige, as is VSOP brandy. Chinese 'wine' is worth a try at least once, though it is generally made from flowers, herbs and grains (rice and millet), and with an alcohol content around 70 per cent is actually more of a spirit than a wine. *Mao tai* and *kao ling* are two of the most powerful, while *sui hing* is often served warm on winter days.

Au Trou Normand (£££)

Replicates the rustic feel of a French farmhouse setting. In business over 30 years with many tried and tested French favourites. A good choice for a special meal.

✉ Ground Floor, 6 Carnarvon Road, Tsim Sha Tsui ☎ 2366 8754 🕐 Daily 12–3, 7–11 🚇 Tsim Sha Tsui

Banana Leaf Curry House (£)

A relaxed and amiable restaurant where the Malaysian and Singaporean curries and other dishes are eaten from banana leaves in the traditional manner (knife and fork are provided). Be sure to try one of the many fresh fruit juices.

✉ 3rd Floor, Golden Crown Court, 68 Nathan Road, Tsim Sha Tsui ☎ 2721 4821
🕐 Mon–Fri 11–3, 6–11:30; Sat–Sun 11–11:30 🚇 Tsim Sha Tsui

Bohdi Vegetarian (£)

A good, reasonably priced chain of Chinese restaurants with a wide range of dishes which should also appeal to non-vegetarians. Most outlets have a take away or stand-up counter service as well as waiter service. No alcohol is served.

✉ 56 Cameron Road, Tsim Sha Tsui ☎ 2739 2222 🕐 Daily 12–2:30, 6–10:30 🚇 Tsim Sha Tsui

Bostonian American Bar & Restaurant (£££)

An in-house hotel restaurant serving modern food, with an emphasis on steaks, seafood and Cajun-Creole dishes: particularly good for its superb buffet lunch, salads and desserts.

✉ Lower Lobby, Renaissance Hotel, 8 Peking Road, Tsim Sha Tsui ☎ 2375 1133 ext 2070
🕐 Mon–Sat 12–3, 6:30–11; Sun 11:30–3 (brunch), 6:30–11 🚇 Tsim Sha Sui

Dan Ryan's Chicago Grill (££)

(► 92)

✉ Shop 200, Ocean Terminal, Harbour City, Tsim Sha Tsui ☎ 2735 6111 🕐 Mon–Fri 11:30–12; Sat–Sun 10AM–midnight 🚇 Tsim Sha Tsui

Felix (£££)

This dazzling Philippe Starck-designed French restaurant atop the Peninsula Hotel is one of *the* places to eat in Hong Kong if money is no object. Views over the city at night are as impressive as the sublime food.

✉ 28th Floor, Peninsula Hotel, Salisbury Road, Tsim Sha Tsui ☎ 2366 6251 ext 3188
🕐 Daily 6PM–2AM 🚇 Tsim Sha Tsui 🛈 Reservations and smart dress recommended

Fook Lam Moon (£££)

(► 92)

✉ Shop 8, 1F, 53–59 Kimberley Road, Tsim Sha Tsui ☎ 2366 0286 🕐 Daily 11:30–11:30; *dim sum* 11:30–3 🚇 Tsim Sha Tsui

Gaddi's (£££)

Located in the famous Peninsula hotel, this has been one of the city's grandest dining spots for over 40 years. Matchless food (predominantly French), impeccable service and majestic décor make for a memorable meal.

✉ Peninsula Hotel, Salisbury Road, Tsim Sha Tsui ☎ 2366 6251 ext 3171 🕐 Daily 12–2:30, 7–11 🚇 Tsim Sha Tsui 🛈 Very expensive. Reservations essential. Jacket and tie for men

Gaylord (££)

Founded in 1972, this was one of Hong Kong's first mainstream Indian restaurants and has been a hit with visitors and ex-pats ever since. *Tandoori* dishes are especially good.

✉ 1st Floor, Ashley Centre, 23–25 Ashley Road, Tsim Sha Tsui ☎ 2376 1001 🕔 Daily 11:45–3, 6–11:30 🚇 Tsim Sha Tsui

Golden Bull (££)

The Golden Bull's two outlets offer above average Vietnamese food in stylish surroundings. Specialities are barbecued chicken in red bean curd sauce and grilled jumbo prawns in garlic butter, but the 'seven kinds of beef' and mixed meat *satay* are also tempting.

✉ 101 Ocean Centre, Harbour City, 5 Canton Road, Tsim Sha Tsui ☎ 2730 4866 🕔 Daily 12–11:30 🚇 Tsim Sha Tsui
✉ Level 1, 17 New World Centre, 18 Salisbury Road, Tsim Sha Tsui ☎ 2369 4617 🕔 Daily 12–11:30 🚇 Tsim Sha Tsui

Great Shanghai (£–££)

Ignore the drab décor – part of the atmosphere – and allow the friendly waiters to take you through some of the 400 often adventurous menu items, tried and tested over the course of 25 years. The first choice in the area for Shanghai cuisine.

✉ 26 Prat Avenue, Tsim Sha Tsui ☎ 2366 8158 🕔 Daily 11–11 🚇 Tsim Sha Tsui

Hugo's (£££)

The rarefied atmosphere, strolling players and complimentary flowers and cigars may not be to all tastes; but Hugo's is ideal for a celebrity-style dinner.

✉ 2nd Floor, Hyatt Regency Hotel, 67 Nathan Road, Tsim Sha Tsui ☎ 2311 1234 🕔 Mon–Sat 12–3, 7–11; Sun 11:30–3, 7–11 🚇 Tsim Sha Tsui
❓ Very expensive. Reservations essential

Lai Ching Heen (£££)

High prices are worth paying for what is considered some of the finest and most innovative Cantonese cooking in the city. Service is polished, the ambience calm and elegant, and the harbour views appealing.

✉ Regent Hotel, 18 Salisbury Road, Tsim Sha Tsui ☎ 2721 1211 ext 2243 🕔 Daily 12–2:30, 6–11; *dim sum* 12– 2:30 🚇 Tsim Sha Tsui

Peking Garden (££)

(▶ 94)

✉ 3rd Floor, Star House, 3 Salisbury Road, Tsim Sha Tsui ☎ 2735 8211 🕔 Mon–Sat 11:30–3, 5:30–12; Sun 10:30–3, 5:30–12 🚇 Tsim Sha Tsui

Sagano (£££)

One of the most popular Japanese restaurants, located in a Japanese hotel; chefs and ingredients are also mostly Japanese. The emphasis is on the *kansai* cuisine of the Kyoto region, cooking which favours light sauces and the freshest possible ingredients. The restaurant's harbour-facing glass wall provides memorable city views.

✉ Hotel Nikko, 72 Mody Road, Tsim Sha Tsui East ☎ 2313 4215 🕔 Daily 7–9:30, 12–2:30, 6–10:30 🚇 Tsim Sha Tsui

San Francisco Steak House (££)

In business for over two decades serving up filling and reliable North American classics which include steaks, salmon, clam chowder and some of the best burgers in the city.

✉ Basement, Bank of Tokyo Building, 7 Ashley Road at the corner with Peking Road, Tsim Sha Tsui ☎ 2735 7576 🕔 Daily 12–12 🚇 Tsim Sha Tsui

Indian and Japanese

You have to be careful in Hong Kong's Indian restaurants. They offer some of the city's cheapest dining experiences, but ambience, food – and occasionally hygiene standards – are not what they might be. Most of the better places tend to offer northern Indian cuisine, which is relatively mild and focuses on *tandoori*-cooked meats: at lunch you might try curry buffets or plump for *thali*, a tray of house specialities which allows you to taste a range of different dishes. Japanese restaurants are at the opposite end of the price scale, but you can keep prices down by choosing a multi-course set meal (*kaiseki*) or avoiding the more expensive fish dishes – notably *sushi* and *sashimi* – in favour of hotpots such as *sukiyaki*, *tempura* (deep-fried fish and vegetables) or *teriyaki* beef and pork dishes.

Hong Kong Island

Prices

The price brackets used here are for a double/twin room. Prices can vary considerably, both within any one hotel, and according to season:

(£) = under HK$1,000
(££) = HK$1,000–2,000
(£££) = over HK$2,000

Booking

Hong Kong has one of the world's highest hotel occupancy rates. Its supply of beds is also falling behind demand, which means it is well worth booking accommodation in advance. This is particularly true in the traditionally busy periods of Chinese New Year (January/February), March and mid-September to December, though it is usually high season in Hong Kong for most of the year. You also particularly need to book popular up-market or luxury hotels, of which Hong Kong has a disproportionately large number, and especially those in Central, by far the city's best location. If you arrive without a booking the Hong Kong Hotel Association (HKHA) office in the airport will help you find a room. There is no fee. The HKHA also issues an annual *Official Hotel Guide*.

Bishop Lei International House (£)

A superior hostel-type hotel run by the Catholic church in the Mid-Levels residential district. At the top of the budget price range with 207 rooms that are clean and institutional in the best sense. Facilities include outdoor pool, exercise centre, restaurant and coffee shop.
✉ **4 Robinson Road, Mid-Levels** ☎ **2868 0828; fax 2868 1551** 🚇 **Central**

Century(££)

A modern-looking and well-located 23-storey hotel, which opened in 1992. Reasonable rates and just a few minutes from the MTR station. Restaurant, bar, gym and open-air pool.
✉ **238 Jaffe Road, Wan Chai** ☎ **2598 8888; fax 2598 8866** 🚇 **Wan Chai**

Charterhouse (£££)

A pleasantly small and newish hotel in a relatively quiet Wan Chai location. Rooms are modestly sized, while dining rooms and the range of facilities are excellent. Handily situated for shopping areas.
✉ **209–219 Wan Chai Road, Wan Chai** ☎ **2833 5566; fax 2833 5888** 🚇 **Wan Chai or Causeway Bay**

Conrad International (£££)

Built in 1990 and located in a Pacific Place tower with magnificent views. Its big and glitzy ambience, shared with the Island Shangri-La, may not be to all tastes. Spacious, well-designed rooms, a range of excellent restaurants and numerous facilities, including one of the city's best fitness centres.
✉ **Pacific Place, 88 Queensway, Central** ☎ **2521 3838; fax 2521 3888** 🚇 **Admiralty**

Emerald (££)

More outlying than most hotels, but reasonable proximity to an MTR station provides easy access to the rest of Hong Kong Island. Rooms are good, and some have harbour views.
✉ **152 Connaught Road, Sheung Wan** ☎ **2546 8111; fax 2559 0255** 🚇 **Sheung Wan**

Empire Hotel (££)

Plum in the heart of the Wan Chai district close to the New Harbour and Wharney hotels, but also convenient for Central sights and locations. At the lower end of its price bracket.
✉ **33 Hennessy Road, Wan Chai** ☎ **2866 9111; fax 2861 3121** 🚇 **Wan Chai**

Excelsior (£££)

Long-established and a perennial favourite with groups, business and vacation visitors. Relaxed atmosphere but some way away from Central, though well located for Causeway Bay's shops and Wan Chai nightlife. Rooms and facilities a touch dated by comparison with newer rivals, but rates are also more reasonable: the first choice in its category in the Causeway Bay area.
✉ **281 Gloucester Road, Causeway Bay** ☎ **2894 8888; fax 2895 6459** 🚇 **Causeway Bay**

Garden View International House (£)

Central's only true budget option. Book well in advance

to secure one of the clean, neat rooms in this YWCA-run hotel on the slopes overlooking the botanical gardens and city below. Guests have access to a pool and fitness facilities.

✉ 1 MacDonnell Road, Central
☎ 2877 3737; fax 2845 6263
🚇 12a

Grand Hyatt (£££)

A sleek, marble-fronted luxury hotel with waterfront location and superb views housed in the Convention and Exhibition Centre. It is aimed at the upper bracket business market, but the facilities, bars, clubs and renowned restaurants will appeal to all.

✉ 1 Harbour Road, Wan Chai
☎ 2588 1234; fax 2802 0677
🚇 Wan Chai

Harbour View International House (££)

The 320 rooms in this waterfront YMCA are small and plain, but they are also clean and cheap, making this one of the best-value and best-located mid-price options on Hong Kong Island. Try for rooms with harbour views.

✉ 4 Harbour Road, Wan Chai
☎ 2802 0111; fax 2802 9063
🚇 Wan Chai

Island Shangri-La (£££)

Part of a luxury Asian chain opened with the Conrad International in 1990 in a tower of Pacific Place. There are dazzling views of the Peak or harbour from the superbly finished rooms and majestic marble-decked lobbies and common parts. However, the road system near by means the position is not terribly convenient should you want to walk to Central.

✉ Pacific Place, Supreme Court Road, Central ☎ 2877 3838; fax 2521 8742 🚇 Admiralty

J W Marriott (£££)

First of the up-market hotels to open in the prestigious Pacific Place development. Like the Conrad International and Island Shangri-La, most of the bright and spacious rooms have wide-reaching city views. Countless facilities and room amenities, including pool and fitness centre.

✉ Pacific Place, 88 Queensway, Central ☎ 2810 8366; fax 2845 0737 🚇 Admiralty

Luk Kwok (££)

A smart, modern and striking hotel designed by Remo Riva, one of the city's leading architects. The location is good and all rooms are neat and calm, though only those on the upper floors have memorable views.

✉ 72 Gloucester Road, Wan Chai ☎ 2866 2166; fax 2866 2622 🚇 Wan Chai

Mandarin Oriental (£££)

One of the world's best hotels, and in the past a first choice in the luxury bracket on Hong Kong Island, though the nearby Ritz-Carlton is now a serious rival. Fully deserves its reputation, in particular for its outstanding service and attention to detail.

🏨 5 Connaught Road, Central ☎ 2522 0111; fax 2810 6190 🚇 Central

New Cathay (££)

A relatively plain and well-priced hotel whose rooms are small but equipped with essentials such as TV and air-conditioning. Popular with tour parties and budget travellers. An easterly Causeway Bay location on the fringe of Victoria Park. Good for single travellers.

✉ 17 Tung Lo Wan Road, Causeway Bay ☎ 2577 8211; fax 2576 9365 🚇 Causeway Bay

Location

Hong Kong has some of the finest luxury hotels in the world. Service, facilities, rooms, restaurants and lobbies in all such hotels should be first rate. If money is no object you should aim to stay on Hong Kong Island, the only exception being if you want to sample the famous old-world style of the Peninsula hotel in Kowloon. On Hong Kong Island there is no substitute for a location at the heart of the Central district, which narrows your choice down to the Mandarin and Ritz-Carlton. Other luxury hotels such as the Shangri-La are a little further away from the heart of Central, only a problem if you like to walk out of your hotel to the sights. Wan Chai is a definite second best, Causeway Bay a third choice. In Kowloon the first choice is the Peninsula, with the Regent, Hyatt Regency and Kowloon Shangri-La close behind.

Facilities
It is well worth checking on the facilities you can expect to find in your hotel. Most should have in-house bars, cafés and restaurants, and most of the more modern and up-market hotels should have facilities such as fax and modem points for business travellers. Some hotels also offer indoor or outdoor swimming pools, tennis and squash courts, saunas, massage and state-of-the-art health and fitness centres.

New Harbour (££)
A potentially noisy location, though the rates are good for a hotel in this relatively central position. Rooms and communal areas are fairly modest, but you are close to an MTR station and tram routes to all parts of the city.
✉ 41–9 Hennessy Road, Wan Chai ☎ 2861 1166; fax 2865 6111 🚇 Wan Chai

New World Harbour View (£££)
Most rooms are cheaper and smaller than those of the Grand Hyatt, a rival hotel located in the same Convention Centre complex, though the views, luxury touches and facilities make it similarly appealing.
✉ 1 Harbour Road, Wan Chai ☎ 2802 8888; fax 2802 8833 🚇 Wan Chai

Noble Hostel (£)
A top-rate hostel with an excellent reputation – so book ahead – which has expanded over the years to occupy several buildings. Rooms are clean and all come with air-conditioning and TV; also with and without private bathrooms.
✉ Main Office, Flat A3, 17th Floor, 27 Paterson Street, Causeway Bay ☎ 2576 6148; fax 2577 0847 🚇 Causeway Bay

Regal Hong Kong (£££)
Decoration and fittings in this 33-storey hotel, opened in 1993, are European in flavour and smart almost to the point of excess. Located a little further east and therefore less central than the Excelsior, its main Causeway Bay district rival.
✉ 88 Yee Wo Street, Causeway Bay ☎ 2890 6633; fax 2881 0777 🚇 Causeway Bay

Ritz-Carlton (£££)
The best luxury hotel on Hong Kong Island, though devotees of the nearby Mandarin may disagree. Has a better position – at the heart of Central – than the Island Shangri-La, its other chief rival, and scores over all its competitors thanks to its refined and intimate ambience and the traditional nature of its décor and approach. Opened in 1993, it has tremendous style, rooms with superb harbour or city views, and all the attention to detail you would expect of a hotel of this class.
✉ 3 Connaught Road, Central ☎ 2877 6666; fax 2877 6778 🚇 Central

South Pacific (££)
A slightly outlying position, equidistant between two MTR stations, means this strikingly designed hotel is quieter than most. Rooms are spacious. Nearby trams provide easy access to central locations.
✉ 23 Morrison Hill Road, Causeway Bay ☎ 2572 3838; fax 2893 7773 🚇 Wan Chai or Causeway Bay

Wesley (£)
A 21-storey hotel with 251 rooms, opened in 1992 close to Pacific Place and the junction of Queensway, offers remarkably reasonable rates by Hong Kong Island standards. Rooms are modest but nicely appointed.
✉ 22 Hennessy Road, Wan Chai ☎ 2866 6688; fax 2866 6633 🚇 Wan Chai

Wharney Hotel (££)
Pleasant, convenient and reliable hotel with facilities such as an indoor pool and health club which raise it above the ordinary. The location, close to the Convention Centre, is good and reasonably quiet.
✉ 57–73 Lockhart Road, Wan Chai ☎ 2861 1000; fax 2865 6023 🚇 Wan Chai

Kowloon

Bangkok Royal (£)
Located close to the junction of Austin Road and Nathan Road and to the MTR station: a short walk to the centre of the Tsim Sha Tsui shopping and nightlife district. The 70 rooms are clean, if simple and slightly worn.

✉ 2–12 Pilkem Street, Yau Ma Tei ☎ 2735 9181; fax 2730 2209 🚇 Jordan

Booth Lodge (£)
This modern, efficient and bright 53-room hotel close to the Jade Market is named after the founder of the Salvation Army, the body that runs the establishment. It dates from 1985 and offers very reasonable rates. A small café provides snacks and meals.

✉ 11 Wing Sing Lane, Yau Ma Tei ☎ 2771 9266; fax 2385 1140 🚇 Yau Ma Tei

Caritas Bianchi Lodge (£)
Located close to the Jade and Temple Street markets and almost alongside the Booth Lodge (▶ above). A brisk, clean and friendly place administered by the Catholic church. Most of the 90 rooms have TV and private bathroom. A Continental breakfast is included in the room rate.

✉ 4 Cliff Road, Yau Ma Tei ☎ 2388 1111; fax 2770 6669 🚇 Yau Ma Tei

Grand Stanford Harbour View (£££)
Better priced than many hotels in this category – it was formally a Holiday Inn – but the eastern location is some distance from an MTR station: ferry connections are most convenient. Big, comfortable rooms, some with views, and all the usual comforts and facilities.

✉ 70 Mody Road, Tsim Sha Tsui East ☎ 2721 5161; fax 2732 2233 🚇 Tsim Sha Tsui 🚢 Hung Hom Ferry Pier

Harbour Plaza (£££)
Opened in 1995, this is one of Hong Kong's newest hotels. The easterly location is some 20 minutes by ferry from the Central or Wan Chai piers on Hong Kong Island.

✉ 20 Tak Fung Street, Hung Hom ☎ 2621 3188; fax 2621 3311 🚢 Hung Hom Ferry Pier

Holiday Inn Golden Mile (££)
A hotel dating from 1975 on the so-called 'Golden Mile' of Nathan Road, epicentre of Kowloon's bustling commercial and shopping district. The 509 rooms, including singles, are a good size, brightly decorated and fairly priced. Facilities include pool and a choice of cafés and restaurants.

✉ 50 Nathan Road, Tsim Sha Tsui ☎ 2369 3111; fax 2369 8016 🚇 Tsim Sha Tsui

Hongkong (£££)
One of the Marco Polo group of three hotels, formerly known as the Omni hotels, which occupy the smart Harbour City complex close to the Star Ferry terminal. Rooms are pleasing but relatively simple, though rates are also a touch lower than others in this category.

✉ Harbour City, 3 Canton Road, Tsim Sha Tsui ☎ 2113 0088; fax 2113 0011 🚇 Tsim Sha Tsui

Hotel Tips
Travel agents in Hong Kong or in your home country should be able to secure significant discounts on the official listed prices of rooms in many Hong Kong hotels. This is particularly true of hotels in these pages' (£££) and (££) brackets. Note, too, that room rates within a hotel often vary considerably, sometimes by as much as HK$1,000. Rooms without views, for example, are usually cheaper. Be sure to enquire about alternative rooms, and do not necessarily accept the first room you are shown. Also try to have breakfast included in your room tariff: hotel breakfasts are usually big enough to set you up for the day.

Closure
Guest houses and other cheap accommodation tend to close or change management at short notice, so always call ahead to make sure they are still in operation. Most cheaper places are not listed in the HKTA's official hotel guide, though that does not mean they do not exist. However, if you have trouble finding accommodation in the budget range it is still worth asking the HKTA for assistance.

YMCAS
These are a sound choice for visitors on a budget, but you may need to book up to two months in advance for the most popular of Hong Kong's YMCA-run hotels, located centrally in Salisbury Road. The larger YMCA International House also offers simple, clean rooms at reasonable prices.
✉ 41 Salisbury Road, Tsim Sha Tsui ☎ 2369 2211; 2739 9315 🚇 Tsim Sha Tsui
✉ 23 Waterloo Road, Yau Ma Tei ☎ 2771 9111; fax 2771 5238 🚇 Yau Ma Tei

Hong Kong Renaissance (£££)
Tasteful up-market touches embellish this 19-storey hotel, with a pronounced European flavour: pool, health club and other facilities, plus five restaurants. As usual, rooms with harbour views command higher prices.
✉ 8 Peking Road, Tsim Sha Tsui ☎ 2375 1133; fax 2375 6611 🚇 Tsim Sha Tsui

Hyatt Regency (£££)
Recent renovations have added lustre to what was already one of Kowloon's top-choice up-market hotels. Well located, especially for shoppers, and some fine in-house restaurants.
✉ 67 Nathan Road, Tsim Sha Tsui ☎ 2311 1234; fax 2739 8701 🚇 Tsim Sha Tsui

Imperial (££)
The 200 or so rooms are modest and facilities comparatively few, but this hotel is good value and at the lower end of its price bracket: places are rare in this sort of location and at this price, so be sure to book ahead.
✉ 30–34 Nathan Road, Tsim Sha Tsui ☎ 2366 2201; fax 2311 2360 🚇 Tsim Sha Tsui

International (£)
A slightly austere-looking hotel with few frills. Offers reasonable value and 89 large, acceptably decorated rooms, the best overlooking Cameron Road.
✉ 33 Cameron Road, Tsim Sha Tsui ☎ 2366 3381; fax 2369 5381 🚇 Tsim Sha Tsui

Kowloon Hotel (££)
A good first choice in this category, despite the rooms, which make up for in amenities and appearance what they lack in size. Good location and access to the facilities of the nearby Peninsula, which is under the same management.
✉ 19–21 Nathan Road, Tsim Sha Tsui ☎ 2369 8698; fax 2739 9811 🚇 Tsim Sha Tsui

Kowloon Shangri-La (£££)
Business travellers return again and again to a hotel that in the past has been ranked among the world's top ten. Immaculate service and attention to detail. Large rooms and a range of restaurants to cater to most tastes. Only the location could be better.
✉ 64 Mody Road, Tsim Sha Tsui East ☎ 2721 2111; fax 2723 8686 🚇 Tsim Sha Tsui

Majestic (£)
At the top of this price category, but the higher price buys efficient service and a smart bar and restaurant. The 387 rooms are modern, if rather thinly furnished. The hotel complex also includes a mall and two cinemas.
✉ 348 Nathan Road, Yau Ma Tei ☎ 2781 1333; fax 2781 1773 🚇 Jordan

Miramar (££)
A big and often busy hotel built in the 1950s alongside Kowloon Park, though only the top floor rooms enjoy park views. Many rooms are much larger than the Hong Kong average.
✉ 130 Nathan Road, Tsim Sha Tsui ☎ 2368 1111; fax 2369 1788 🚇 Tsim Sha Tsui

New World (££)
Built in the 1970s and recently spruced up to

provide 550 modern and well-appointed rooms. At the top of its price range, it offers lovely landscaped gardens and six restaurants.

✉ 22 Salisbury Road, Tsim Sha Tsui ☎ 2369 4111; fax 2369 9387 🚇 Tsim Sha Tsui

Peninsula (£££)

The 'Pen' vies with the Mandarin for the title of Hong Kong's most famous hotel, and with the Regent for the best place to stay in the luxury bracket in Kowloon. Built in 1928, so has much more old-world character than its rivals; a new tower annex was added in 1994. Facilities, service and luxury touches are all impeccable (➤ 78).

✉ Salisbury Road, Tsim Sha Tsui ☎ 2366 6251; fax 2722 4170 🚇 Tsim Sa Tsui

Prince (££)

One of three reliable hotels located in the conveniently situated Harbour City complex (others are the Hongkong and Marco Polo). Shops, nightlife and transport links are all close at hand. Many rooms have views over Kowloon Park.

✉ Harbour City, Canton Road, Tsim Sha Tsui ☎ 2113 1888; fax 2113 0066 🚇 Tsim Sha Tsui

Regal Kowloon (££)

The flavour of France runs through much of this hotel, opened in the mid-1980s, from its restaurants to the tapestries and furniture of the lobby. Situated east of Tsim Sha Tsui's heart, but still within walking distance of transport and shopping.

✉ 71 Mody Road, Tsim Sha Tsui East ☎ 2722 1818; fax 2369 6950 🚇 Tsim Sha Tsui

Regent (£££)

The waterfront location offers spectacular views from many rooms in a modern hotel that provides the Peninsula with its main competition among Kowloon's luxury hotels. Contains all the features and facilities you would expect from a hotel of the first rank.

✉ 18 Salisbury Road, Tsim Sha Tsui ☎ 2721 1211; fax 2739 4546 🚇 Tsim Sha Tsui

Shamrock (£)

The Shamrock is basic but well located just north of Kowloon Park close to bus stops and an MTR station. This 148-room hotel is slightly showing its age, but still represents good value, offering rooms that are airy but hardly state of the art.

✉ 223 Nathan Road, Yau Ma Tei ☎ 2735 2271; fax 2736 7354 🚇 Jordan

Sheraton (£££)

Courtyard or harbour views are available from most of the 806 modern rooms in this reliable hotel at the southern end of Nathan Road (convenient for the Star Ferry to Central). Good fitness centre, rooftop pool and terrace.

✉ 20 Nathan Road, Tsim Sha Tsui ☎ 2369 1111; fax 2739 8707 🚇 Tsim Sha Tsui

Windsor (£)

More expensive than some places in this category, but the 166 rooms are clean, reasonably smart and well placed just east of Tsim Sha Shui's main shopping and entertainment district.

✉ 39–43a Kimberley Road, Tsim Sha Tsui ☎ 2739 5665; fax 2311 5101 🚇 Tsim Sha Tsui

Chungking Mansions

Chungking Mansions, at 36–44 Nathan Road, have been notorious among budget travellers for years. The big and extremely dingy block contains a warren of guest houses, some of a nastiness hard to imagine. In the past the block was regularly raided and various places shut down for breaches of fire and other regulations. These days some of the worst places have been closed permanently, and safety standards are more vigorously enforced. Lifts and stairwells, however, still have a Dantesque quality. If you are travelling on a tight budget this could well be your first port of call. Simply wander the floors and enquire at the various guest houses. One way or another, you are unlikely to forget your stay.

Department Stores

Shopping Tips I

• Try to shop at stores with the HKTA symbol of approval and affiliation
• Be sure to pick up the HKTA *Official Shopping Guide* pamphlet
• Prices in Hong Kong for cameras, computers and other electrical goods are usually similar to those in Europe and often *higher* than in the USA
• Bring details and prices of products from home to be sure you are comparing the same brand and model numbers

China Products Company

A chain selling Chinese products at moderate prices, with household items particularly good buys.
✉ **19–31 Yee Wo Street, Causeway Bay, Hong Kong Island** ☎ **2890 8321** 🕓 **Daily 9–9** 🚇 **Causeway Bay**
✉ **54 Nathan Road, Tsim Sha Tsui, Kowloon** ☎ **2739 3839**

Chinese Arts and Crafts

Highly Western-oriented stores devoted to Chinese goods, good for silk clothing, jewellery, carpets, *objets d'art* and other Chinese items. Prices are relatively high for this type of product, but still good value.
✉ **26 Harbour Road, Wan Chai, Hong Kong Island** ☎ **2845 0092** 🕓 **Daily 9–9** 🚇 **Central**

Chung Kiu

Like Yue Hwa, shops in this chain offer good selections of arts and crafts, as well as sumptuous silks and lots of traditional clothing.
✉ **Chung Kiu Commercial Building, 47–51 Shan Tung Street, Mong Kok, Kowloon** ☎ **2780 2331** 🕓 **Daily 9 –late** 🚇 **Mong Kok** ✉ **528–532 Nathan Road, Yau Ma Tei, Kowloon** ☎ **2780 2351** 🕓 **Daily 10 –late** 🚇 **Yau Ma Tei**

Lane Crawford

The oldest, most prestigious and most luxurious Western-style shop: the one essential department store (▶ 105, Times Square).
✉ **Lane Crawford House, 70 Queen's Road, Central, Hong Kong Island** ☎ **2526 6121** 🕓 **Daily 10–7** 🚇 **Central**

Seibu

A stunning Japanese store, smarter and more prestigious than its many rivals, but also selling Western products. Ideal for exotic gifts. Be sure to visit the food hall.
✉ **Pacific Place Mall, 88 Queensway, Central, Hong Kong Island** ☎ **2877 3627** 🕓 **Daily 9–9** 🚇 **Admiralty**

Shanghai Tang

The numerous colourful shopping bags advertising its purchases give the game away. A favourite among expats, this wonderfully decorated and intimate store is crammed with an eclectic and at times eccentric collection of Chinese and other goods. Highlights include silk pyjamas, Chinese hats in fluorescent colours, Chairman Mao watches and superbly coloured linen. The gift wrapping is a work of art. Come here for something to take home if you have neither the time nor the patience to shop elsewhere.
✉ **Pedder Building, Pedder Street/8 Theatre Lane, Central, Hong Kong Island** ☎ **2525 7333** 🕓 **Daily 9–7** 🚇 **Central**

Yue Hwa Chinese Products Emporium

There are five outlets in this genuine Chinese chain, though some of its newer stores have a more Western feel. Among the city's best sources of Chinese products the shops also sell popular Chinese medicines.
✉ **Pearl City Plaza, 24–36 Paterson Street, Causeway Bay, Hong Kong Island** ☎ **2808 1363** 🕓 **Daily 9:30–10** 🚇 **Causeway Bay** ✉ **54–64 Nathan Road, Tsim Sha Tsui, Kowloon** ☎ **2368 9165** 🕓 **Daily 10–10** 🚇 **Tsim Sha Tsui**

Shopping Centres

The Landmark
Very chic and exclusive, one of the city's top shopping centres, boasting most of the big designer names. There are also plenty of cafés, of which the Trattoria is the best: watch the *tai tai* at play, the Cantonese word for wife, but now applied more generally to ladies who live to lunch and shop.
✉ **Des Voeux Road and Pedder Street, Central, Hong Kong Island** 🕐 **Daily 9–8** 🚇 **Central**

New World Centre
The most convenient and up-market of Kowloon's shopping complexes, on the waterfront just east of the Hong Kong Cultural Centre, so you can easily drop in after seeing the centre's museums. Has a huge range of shops over four floors: particularly good for jade, silk, and rosewood and lacquer furniture.
✉ **20 Salisbury Road, Tsim Sha Tsui, Kowloon** 🕐 **Daily 9–8** 🚇 **Tsim Sha Tsui**

Ocean Terminal
An absolute monster of a mall – one of the world's biggest – stretching almost interminably along Canton Road. Contains virtually all the major names in world retailing. Accessed on the left immediately you come off the Star Ferry in Kowloon, and so competes for custom with the nearby New World Centre.
✉ **Canton Road, Tsim Sha Tsui, Kowloon** 🕐 **Daily 9–8** 🚇 **Tsim Sha Tsui**

Pacific Place
Hong Kong's best shopping complex, and the one to visit if you visit no other. Boasts hotels, dozens of cafés and restaurants and several mini-malls filled with all the designer names and top quality stores you could ask for. Marks & Spencer and Seibu are also here.
✉ **88 Queensway, Central, Hong Kong Island** 🕐 **Daily 9–8** 🚇 **Admiralty**

Prince's Building
A first-rate standby for basics and more exciting designer shops and other stores. Located at the heart of Central opposite the Mandarin Oriental hotel, so the position could hardly be better. Far more intimate and manage-able than the nearby Landmark complex.
✉ **Chater Road and Des Voeux Road, Central, Hong Kong Island** 🕐 **Daily 9–8** 🚇 **Central**

Shun Tak Centre
This mall waylays you as you emerge from the Sheung Wan MTR station, making a useful standby if the shopping bug hits you while exploring the area west of Central. It contains most of the major Hong Kong chains.
✉ **200 Connaught Road, Sheung Wan, Hong Kong Island** 🕐 **Daily 9–8** 🚇 **Sheung Wan**

Times Square
This mall to end all malls is a modern development with 12 floors filled with most of the top names in retailing. Each level is devoted to a particular type of store, making it easier to negotiate than some malls. The top-ranking Lane Crawford store has an outlet here.
✉ **1 Matheson Street, Causeway Bay, Hong Kong Island** 🕐 **Daily 9–8** 🚇 **Causeway Bay**

Shopping Tips II
• Avoid shops that do not display prices, especially on Nathan Road
• Shop around for the best prices, but be certain you are comparing the same products: many models look similar
• Spend plenty of time getting used to Hong Kong and the way shops do business before making big purchases
• Do not trust retailers to pack and dispatch products to your hotel

Markets

Shopping Tips III
• Check equipment to see that it works and that all extras are included
• Check you do not pay extra for items that should be included in the price (such as camera cases with cameras)
• Most importantly check that the products you bought are the ones that are packed in your bag: switches with faulty or inferior products are not unknown
• Check that receipts include full details of your purchase
• Check guarantees carefully and be sure what they cover (panel ► 107)
• Check voltage, plugs and so on are compatible with the electrical system in your home country

Central Market (► 37)
You may not want to buy anything here, but this four-storey building is the best place in the city centre for a taste of what a real Chinese market looks like: sights and smells are overpowering, to say the least, and the range of vegetables, fish and miscellaneous foodstuffs is overwhelming.
✉ Junction of Queen Victoria Street and Des Voeux Road, Central, Hong Kong Island
🕐 Daily 7–10, 5–8 🚇 Central

Cross Street
This is one of the liveliest street markets in the city, with a mixture of stalls selling food and general goods. Like most similar markets it is fun simply to explore for its sights and sounds. Also look into the covered market just south at the junction of Wan Chai Road and Johnston Road.
✉ Cross Street, Wan Chai, Hong Kong Island 🕐 Daily 10–late 🚇 Wan Chai

Jade Market (► 74)

Jardine's Bazaar
Two narrow and parallel little streets which make up one of Hong Kong's oldest and most authentic street markets. One half is devoted to fruit, vegetables and other food, all colourfully displayed, the rest to a selection of clothes, bags and other 'dry' market goods. The market is close to the Causeway Bay MTR station.
✉ Jardine's Bazaar and Jardine's Crescent, off Yee Wo Street, Causeway Bay, Hong Kong Island 🕐 Daily 10–late 🚇 Causeway Bay

Ladies' Market
So-called because it was once devoted mostly to ladies' clothing. These days the market – a rival to Temple Street in its size, crowds and streetlife – deals in the full range of standard street market goods. Well worth a visit, but only if you don't mind crowds.
✉ Tung Choi Street between Argyle Street and Dundas Street, Mong Kok, Kowloon 🕐 Daily 12–10:30 🚇 Mong Kok

The Lanes
The Lanes are several parallel little streets conveniently situated in Central. Each has stalls and shops selling cheap clothes, leatherware, bags, fabrics, accessories and other general market produce. The best streets are Pottinger, Li Yuen Street East and Li Yuen Street West, the last two some of Hong Kong's oldest market streets.
✉ Li Yuen Street East and Li Yuen Street West, between Queen's Road and Des Voeux Road, Central, Hong Kong Island 🕐 Daily 11–late 🚇 Central ❓ Beware of pickpockets

Stanley Market (► 23)

Temple Street (► 78)
This is best at night, when it teems with people, stalls and intoxicating sounds, sights and smells. Look out for the fortune-tellers and the occasional opera singers tucked away in side alleys.
✉ Temple Street, Kansu Street, Tsim Sha Tsui, Kowloon 🕐 Daily 8AM–11PM 🚇 Jordan ❓ Can become very crowded. Beware of pickpockets

Western Market (► 74)

Cameras & Electrical Goods

Broadway Photo Supply
Broadway Photo Supply is a chain with shops across the city: addresses below detail the main branches. Despite the name, stores sell a full range of cameras and other electrical goods. Prices are more or less fixed, and give a good idea of a reasonable going rate if you want to haggle elsewhere.

✉ **Shop 714–715, 1 Matheson Street, Causeway Bay, Hong Kong Island** ☎ **2506 1330** 🚇 **Causeway Bay**

✉ **Ground Floor & 1st Floor, 731 Nathan Road, Mong Kok, Kowloon** ☎ **2394 3827** 🚇 **Mong Kok**

Continental Computer Systems
One of only a handful of computer stores registered with the Hong Kong Tourist Association (HKTA), meaning it can generally be relied on for honest service and reliable products.

✉ **Room 202, Hing Tai Commercial Building, 114 Wing Lok Street, Sheung Wan, Hong Kong Island** ☎ **2854 2233** 🚇 **Sheung Wan**

Fortress
This chain is a major rival to Broadway Photo, and sells much the same variety of cameras, camcorders, electronic games, hi-fi and other electrical goods. Like its rival its prices are more or less fixed, though this generally makes its stores reliable and problem-free places to shop. Outlets below are the most central.

✉ **Lower Ground & 3rd Floor, Yu Sung Boon Building, 107–111 Des Voeux Road, Central, Hong Kong Island** ☎ **2544 1665** 🚇 **Central**

✉ **Shop 3281, Ocean Terminal, Harbour City, Canton Road, Tsim Sha Tsui, Kowloon** ☎ **2735 8628** 🚇 **Tsim Sha Tsui**

Photo Scientific Appliances
The best of several photographic shops in this street, and one whose range tends to attract professional photographers. Has a good reputation, through prices are not usually open to negotiation.

✉ **Ground Floor, 6 Stanley Street, Central, Hong Kong Island** ☎ **2522 1903** 🚇 **Central**

Star Computer City
Star Computer City is the name given to the second floor of Star House, which is given over almost entirely to shops selling computers and peripherals. The Mastertech Office Automation store here is HKTA-affiliated.

✉ **Star Computer City, 2nd Floor, Star House, 3 Salisbury Road, Tsim Sha Tsui, Kowloon** ☎ **Mastertech Office Automation 2736 7263** 🚇 **Tsim Sha Tsui**

Windsor House
An arcade of computer stores which provides a smarter, more central and more pleasant buying environment than the dingy Golden Shopping Arcade. Products are similar, though, and you should still make all the usual checks before buying. The Muse Limited store (Shop 1153) here is HKTA-affiliated.

✉ **11th–12th Floors, The In Square, Windsor House, 311 Gloucester Road, Causeway Bay, Hong Kong Island** ☎ **Muse Limited 2928 7081** 🚇 **Causeway Bay**

Guarantees
It is vital to check guarantees when buying expensive watches, high-value branded items and all electronic, electrical and photographic equipment. First check the product has *any* sort of guarantee. Then check which of the three basic guarantees pertains. First, a worldwide or international guarantee, which should carry the name and/or symbol of the sole agent in Hong Kong. This is what you want. Check free servicing is included in your home country. Second, a local guarantee, valid only in Hong Kong, usually for a year. Third, a local retailer guarantee, which is virtually worthless. Guarantees should carry a description of the product, with model and serial number, the date of purchase, name and address of the shop, and the shop's official stamp. Note that different products and models of the same brand may carry different guarantees in different shops. Do not be taken in by fancy-looking pieces of paper that guarantee nothing.

Jewellery & Watches

Jewellery

Jewellery is one of the most popular purchases among visitors to Hong Kong. The city's free port and duty-free status mean that gold, pearls, diamonds and other precious and semi-precious stones can be easily imported from around the world. There are hundreds of stores, choice is enormous and standards of craftsmanship high: the city is also the world's leading centre for opal cutting and polishing and it's the third most important diamond trading centre. It is easy to buy cheap and fun jewellery, though it goes without saying that if you are planning to make major purchases you should know what you are doing and shop carefully. Scams are not unknown, particularly where jade is concerned. Shop only at HKTA-affiliated shops and try to pick up the Association's *Official Shopping Guide* pamphlet, which includes a section on jewellery. For information on buying diamonds contact the Diamond Importers Association (☎ 2523 5497).

Chinese Arts and Crafts

These Western-orientated department stores devoted to Chinese goods usually have extended jewellery departments. They provide good sources of reasonably priced watches, gold, jade and costume jewellery.

✉ **Ground Floor, China Resources Building, 26 Harbour Road, Wan Chai, Hong Kong Island** ☎ **2827 6667** 🚇 **Central**

Chow Tai Fook

This up-market chain has some 15 shops on Hong Kong Island and Kowloon. They are good places to shop for jade and for all manner of other high-value stones and top-quality jewellery. The shops below are the most central outlets on Hong Kong Island and Kowloon.

✉ **G2, China Building, Queen's Road, Central, Hong Kong Island** ☎ **2523 7128** 🚇 **Central**

✉ **Shop G13–14, Park Lane, Shopper's Boulevard, 123 Nathan Road, Tsim Sha Tsui, Kowloon** ☎ **2735 7966** 🚇 **Tsim Sha Tsui**

City Chain

This large and popular chain has some 14 stores on Hong Kong Island and 27 in Kowloon. Each offers an excellent variety of mid-priced, fashion and top-of-the-range watches. There are outlets in most malls and shopping centres.

✉ **Shop B47, Basement, Edinburgh Tower, The Landmark, 11–19A Queen's Road, Central, Hong Kong Island** ☎ **2596 0358** 🚇 **Central**

✉ **G-36A, New World Centre, Salisbury Road, Tsim Sha Tsui, Kowloon** ☎ **2724 3573** 🚇 **Tsim Sha Tsui**

K S Sze & Sons

This shop is one of the smartest imaginable, but do not be daunted by this, especially if you are looking for top-quality jewellery, and fairly priced pearls in particular. Gemsland, another nearby shop in the Mandarin hotel arcade, also has a good reputation for its pearls.

✉ **Shop M11, Mandarin Oriental Hotel, 5 Connaught Road, Central, Hong Kong Island** ☎ **2524 2803** 🚇 **Central**

Kai-Yin Lo

Internationally renowned for innovative and beautiful modern designs with an Oriental twist. The jewellery is the best of its type in the city, but prices are high, hence the location of outlets in two of the city's top luxury hotels.

✉ **Shop 373, Pacific Place, 88 Queensway, Central, Hong Kong Island** ☎ **2840 0066** 🚇 **Admiralty**

✉ **Shop M6, Mandarin Oriental Hotel, 5 Connaught Road, Central, Hong Kong Island** ☎ **2524 8238** 🚇 **Central**

✉ **BE-11, Peninsula Hotel Arcade, Salisbury Road, Tsim Sha Tsui, Kowloon** ☎ **2721 9693** 🚇 **Tsim Sha Tsui**

Opal Mine

This is the best-known store in the city for buying opals, and is used to dealing with foreign visitors. All stones are guaranteed and prices are high, but is worth paying a little over the odds as it's easy to be duped when buying opals.

✉ **Ground Floor, Burlington Arcade, 92 Nathan Road, Tsim Sha Tsui, Kowloon** ☎ **2721 9933** 🚇 **Tsim Sha Tsui**

Art, Artefacts & Antiques

Altfield Gallery
One of the city's finest sources of high-quality art and antiques, particularly furniture. A central location and good staff are bonuses.
✉ 248–9, Prince's Building, Chater Road, Central, Hong Kong Island ☎ 2537 6370 🚇 Central

Amazing Grace Elephant Company
A wide and tempting range of reasonably priced curios and miscellaneous artefacts from across Asia. Perfect for the small gift or souvenir.
✉ 348–349, Ocean Centre, Harbour City, Canton Road, Tsim Sha Tsui, Kowloon ☎ 2730 5455 🚇 Tsim Sha Tsui

Cat Street Galleries
A collection of galleries, curio shops and antiques dealers under one roof. The range and quality of items is good, and several stores are affiliated to the HKTA.
✉ 38 Lok Ku Road, Sheung Wan, Hong Kong Island ☎ 2541 8908 🚇 Sheung Wan

Charlotte Horstmann
Specialises in bronze, furniture and carved wood, but also has a wide range of other antiques and traditional arts and crafts objects.
✉ 104 Ocean Terminal, Harbour City, 3 Canton Road, Tsim Sha Tsui, Kowloon ☎ 2735 7167 🚇 Tsim Sha Tsui

Chinese Arts and Crafts
This chain is excellent for beautiful and reasonably priced products: from tea, statues, silks and furniture to hats, pottery, gemstones and jewellery (► 104).
✉ 230 The Mall, Pacific Place, Queensway, Central, ☎ 2523 3933 🚇 Admiralty
✉ Star House, 3 Salisbury Road, Tsim Sha Tsui, Kowloon ☎ 2735 4061 🚇 Tsim Sha Tsui

Eastern Dreams
A good HKTA-affiliated source of reproduction furniture and other artefacts situated in Hong Kong's 'Antiques Row'. Also at 4 Shelley Street in Central.
✉ Ground Floor, 47A Hollywood Road, Central, Hong Kong Island ☎ 2544 2804 or 2524 4787 🚇 Central

Grace Wu Bruce
The city's best for furniture, particularly Ming pieces and traditional Chinese hardwoods. Like most art and antiques shops the store is happy to arrange export.
✉ 701 Universal Trade Centre, 3 Arbuthnot Road, Central, Hong Kong Island ☎ 2537 1288 🚇 Central

Teresa Coleman
For those in the know this is probably the finest shop in the city for the very highest quality (and most expensive) ivory, *objets d'art*, embroidered clothing and other exquisite antiques.
✉ Ground Floor, 79 Wyndham Street, Central, Hong Kong Island ☎ 2526 2450 🚇 Central

Yue Po Chai
One of the oldest antiques shops on Hollywood Road, with a huge and fascinating stock. It is very strong on ceramics. Also at 161 Hollywood Road.
✉ Ground Floor, 132–136 Hollywood Road, Central, Hong Kong Island ☎ 2540 4374 or 2543 8022 🚇 Central

Exporting Goods
New laws following the 1997 handover may well prevent the export from Hong Kong of Chinese 'national treasures' and articles over 120 years old. In practice 'antique' in Hong Kong has often referred to something that looks old, or might be old, rather than something genuinely antique, so new legislation will probably have little effect on the city's antiques trade. Many shops in any case sell high-quality reproductions, and draw few distinctions between antiques and 'arts and crafts'. This said, the quality and range of objects are excellent. For browsing your first port of call should be Hollywood Road and Cat Street (► 49), home to numerous antique, curio and junk shops. Most shops will happily handle any shipping arrangements. High-value purchases should be adequately insured. Also check there are no customs complications involved in importing goods into your home country.

Children's Hong Kong

Free Concerts
Local musicians often hold free lunchtime concerts on Wednesday in St John's Cathedral in Central on Hong Kong Island (► 59). For more details and current times ☎ 2523 4157. The Cultural Centre, Arts Centre and Academy for Performing Arts also organise occasional free concerts (► 111).

Hong Kong is crowded, so keep a careful watch on children on streets, buses and on the Star Ferry. The city is also hot and humid, so make sure children have a sun hat, wear suncream and drink sufficient water. Beware of cats and dogs – rabies can be a problem – and steer clear of 'wet' markets, where fish and animal displays are likely to upset small children (not to mention adults). Chinese families often take children out to eat, so restaurants should pose few problems: most should be able to provide high chairs. Many tourist attractions and tours offer discounts for children.

Museums
Some of Hong Kong's best museums should appeal to children of all ages. Most notable among the many on offer is the tremendous Hong Kong Science Museum (► 21), whose range of hands-on and interactive displays should keep kids happy for hours. The Hong Kong Space Museum (► 22) is not quite as large or as high-tech, but it still offers the right combination of hard facts and fun interaction to appeal to older and more scientifically inquisitive children.

Outings
The single most obvious outing with children in Hong Kong is to Ocean World and the adjacent Water World, two attractions designed specifically with youngsters in mind (► 20). The thrill of riding the Star Ferry (► 24) or making longer boat trips to outlying islands such as

Lamma and Lantau (► 84) should also keep children happy. So should the novelty of the steep ride on the Peak Tram, not to mention the views from the Peak Tower (► 26). Riding upstairs on city trams might also appeal to youngsters.

Gardens, Parks and Temples
Smaller children might grumble about the steps and climbs involved in wandering around Hong Kong Park and the Zoological and Botanical Gardens, but the aviaries in both these venues, as well as the animals in the latter, should go some way toward stifling complaints. You might also try the Aw Boon Haw (Tiger Balm) Gardens (► 32). Older children might be fascinated by temples such as Man Mo (► 18) and Wong Tai Sin (► 88).

Tours and Activities
Visitors should contact the Hong Kong Tourist Association (HKTA) offices (► 118) for details of their many tours and for information regarding activities such as horse riding, roller-skating, bowling and roller-blading, which might appeal to children. One of the Association's tours particularly worth pursuing might be the Family Insight Tour, which takes you to typical Hong Kong Chinese houses, nursery schools and temples. Alternatively, you could contact Watertours (☎ 2730 6171), which offers cruises around the harbour and islands aboard traditional Chinese-style junks.

Performance Venues

City Hall
A premier venue, offering a wide range of local and international classical theatre, music, dance, film and art exhibitions. It boasts a separate theatre, concert hall and sizeable auditorium.
✉ 7 Edinburgh Place, Central, Hong Kong Island ☎ 2921 2840 🕙 Box office 10–9:30 🚇 Central

Hong Kong Academy for Performing Arts
The 1,600-seat auditorium, 200-seat studio theatre and 500-seat outdoor arena host theatre presentations, concerts and dance productions.
✉ 1 Gloucester Road, Wan Chai, Hong Kong Island ☎ 2584 8514 or 2824 2651 🚇 Wan Chai

Hong Kong Arts Centre
A large venue providing the setting for a wide variety of theatrical and other cultural events. Ticket prices are often a touch lower than for events at City Hall and the Cultural Centre. Especially good for independent, classic and documentary films.
✉ 2 Harbour Road, Wan Chai, Hong Kong Island ☎ 2877 1000 🕙 Box office daily 10–6 🚇 Wan Chai

Hong Kong Coliseum
One of the city's largest venues, the 12,000-seat Coliseum sits atop Kowloon's railway station and plays host to a wide range of music, dance and sporting events.
✉ 9 Cheong Wan Road, Hung Hom Railway Station, Hung Hom, Kowloon ☎ 2355 7233 or 2765 9234 🕙 Box office 10–6:30 🚇 Tsim Sha Tsui then by taxi

Hong Kong Convention and Exhibition Centre (► 51)
Commerce occasionally gives way to culture at this huge and impressive waterfront complex, which hosts a variety of concerts, exhibitions and other events.
✉ 1 Harbour Road, Wan Chai, Hong Kong Island ☎ 2582 8888 🚇 Wan Chai

Hong Kong Cultural Centre (► 72)
One of the most prestigious venues for theatrical and other performances, housing a 2,100-seat hall and the 1,750-seat Grand Theatre.
✉ Salisbury Road, Tsim Sha Tsui, Kowloon ☎ 2734 2009 🕙 Box office 10–9:30 🚇 Tsim Sha Tsui

Hong Kong Fringe Club
Principal focus for fringe, avant-garde and alternative performances of theatre, jazz, classical music, poetry and other events. Also good for workshops, classes and temporary exhibitions. A key venue for non-mainstream events during the annual Arts Festival (► 112).
✉ 2 Lower Albert Road, Central, Hong Kong Island ☎ 2521 7251 🚇 Central

Queen Elizabeth Stadium
The name may change in the wake of the Chinese takeover, but the 3,500-stadium will remain. Although devoted primarily to sports events, the venue also occasionally hosts ballet, pop concerts and classical recitals.
✉ 18 Oi Kwan Road, Wan Chai, Hong Kong Island ☎ 2591 1347 🕙 Box office 10–6:30 🚇 Wan Chai

Event Information
Information for most cultural events can be obtained from offices of the Hong Kong Tourist Association (► 118), from telephone calls or personal visits to the venues or from the listings pages of newspapers such as the daily *South China Morning Post* and the free weekly *H K Magazine* (available from many bars, hotels and restaurants). Large bulletin boards outside City Hall by the Star Ferry terminal also contain posters and listings of forthcoming events.

Tickets
Tickets for most events are reasonably priced by Western standards. Tickets for many events can be obtained directly from the relevant box office or from a number of ticket agencies. Among the latter the most prominent is URBTIX (☎ 2734 9009 🕙 Daily 10–9), which has branches at City Hall and the Hong Kong Arts Centre, among other places. The agency also has a useful system for booking and making reservations in advance by phone using a credit card or passport details. Tickets must be collected within three days. Cinema tickets can be booked in the same way through Ticketmaster (☎ 2317 6666 🕙 6AM–11:30PM). You can book tickets up to 30 minutes before each show. Tickets are collected from vending machines outside participating cinemas.

111

Performing Arts

Cinema and Film

The vast majority of Hong Kong cinemas show films in Cantonese, though details of the city's 30 or so English-language cinemas are available from the HKTA offices or papers and listings magazines (panel ➤ 111). Most are multi-screen complexes situated in Causeway Bay. Other cinemas may show first-release films in English with Cantonese subtitles, which means the Chinese can – and do – chatter through the entire film. For fun you might try Cantonese films – martial arts flicks or lightweight gangster and comedy pot-boilers – with English subtitles. Queues are common, but ticketing is computerised: you pick your numbered seat from those remaining when you arrive at the box office. Real film buffs should aim to take in the annual Hong Kong International Film Festival (August), which offers an eclectic mixture of local, Chinese, Asian and other films from across the globe.

Chinese Opera

Hong Kong has ten or so small companies and many amateur troupes devoted to traditional Pekinese, Cantonese and Chiu Chow opera, an ancient and highly esoteric form of street theatre. Performances are rarely scheduled. The stories are often complex and the acting mannered – there are 50 different symbolic gestures for the hands alone. For information contact the HKTA (☎ 2807 6177).

Concerts

Hong Kong Chinese Orchestra

Founded in 1977, this is the world's largest orchestra devoted solely to Chinese works and orchestrations. Performances usually take place at City Hall or the Cultural Centre (☎ 2853 2622 for information).

Hong Kong Philharmonic Orchestra

A large and well-established orchestra comprising local, North American and European members and attracting renowned international soloists and visiting conductors. The season runs from September to July. Performances usually take place at City Hall and the Cultural Centre (☎ 2721 2320 or 2832 7121).

Dance

The Hong Kong Dance Company (☎ 2853 2642), founded in 1981, performs roughly three times monthly at different venues around the city. The emphasis is on modern, folk and classical Chinese dance. The Hong Kong Ballet (☎ 2573 7398) has a more Western bias, and performs classical and contemporary dance at a variety of venues. The City Contemporary Dance Company (☎ 2326 8597) takes Hong Kong as its principal inspiration, with most performances taking place at the Hong Kong Arts Centre (➤ 111).

Festivals

Festival of Asian Arts

This festival is widely regarded as one of the most important of its kind in Asia, and features examples of the performing arts rarely seen outside the region. Held every two years (even-numbered years) between October and November, it embraces over 150 events at a variety of formal and less formal venues across the city.

Hong Kong Arts Festival

The city's premier arts festival, and the year's cultural highpoint, is held over three weeks between January and March. It showcases a wide range of western and Chinese theatre, dance, music and other performing arts.

Hong Kong Fringe Festival

An off-shoot of the official Arts Festival (➤ above), the Fringe provides a wide variety of alternative dance, theatre, comedy and music. Some performances can be a bit hit or miss – though this just adds to the fun – but tickets are cheap and quality is often assured by the presence of outstanding international names. Contact the Fringe Club (➤ 111).

Live Music

Delaney's

Two excellent Irish-themed bar and eating places that offer live folk and traditional Irish music in addition to the draught Guinness, genuine atmosphere and hearty Irish and other food.

✉ **2nd Floor, One Capital Place, 18 Luard Road, Wan Chai, Hong Kong Island** ☎ **2804 2880** ⏰ **Sun–Thu 12–2AM; Fri–Sat 12–3AM. Happy hour 3PM–8PM** 🚇 **Wan Chai**
✉ **Room 1, Ground Floor, Multifield Plaza, 3–7A Prat Avenue, Tsim Sha Tsui, Kowloon** ☎ **2301 3980** ⏰ **Sun–Thu noon–3AM; Fri–Sat noon–5AM. Happy hour 3–8 and 1am to closing time** 🚇 **Tsim Sha Tsui**

Hardy's Folk

Folk and other related music both professional and amateur: a stage is available for anyone to stand up and have a go. It's also good for a meal or a drink, but the atmosphere can turn rowdy at times.

✉ **35 D'Aguilar Street, Central, Hong Kong Island** ☎ **2522 4448** ⏰ **Daily 5:30–2AM. Music nightly from 9:30** 🚇 **Central**

Jazz Club

This is Hong Kong's best and best-known small jazz, soul and R&B venue, dim, intimate and recently revamped. The club has an excellent atmosphere, with friendly staff and patrons, and the bands range from local performers to big-name international acts.

✉ **2nd Floor, California Entertainment Building, 34–36 D'Aguilar Street, Central, Hong Kong Island** ☎ **2845 8477** ⏰ **Daily 7PM–12, later at weekends and concert nights. Happy hour daily 7–9** 🚇 **Central**

Mad Dogs

Two venues and two of the city's most popular 'British-style' pub-restaurants. Both have singers, DJs and occasional bands: the Kowloon venue has more varied clientele (fewer business people) and is more fun.

✉ **Basement Level, Century Square, 1 D'Aguilar Street, Central, Hong Kong Island** ☎ **2810 1000** ⏰ **Mon–Thu 11AM–2AM; Fri 11AM–3AM; Sat 10AM–3AM; Sun 10AM–2AM** 🚇 **Central**
✉ **Basement, 32 Nathan Road, Tsim Sha Tsui, Kowloon** ☎ **2301 2222** ⏰ **Mon–Thu, Sun 8AM–2AM; Fri–Sat 8AM–4AM. Happy hour 4–8** 🚇 **Tsim Sha Tsui**

Ned Kelly's Last Stand

Famous and deservedly well-patronised Aussie-style pub which, in addition to its beer, food and fine atmosphere, also offers barnstorming Dixieland jazz from the resident band, the Kowloon Honkers.

✉ **11A Ashley Road, Tsim Sha Tsui, Kowloon** ☎ **2376 0562** ⏰ **Daily 11:30AM–2AM. Happy hour 4–7** 🚇 **Tsim Sha Tsui** ❓ **No cover charge. Arrive before 9PM to be sure of a seat**

Wanch

First-rate and popular folk and (occasionally) rock music venue with good live performances seven nights weekly. Pleasant, unpretentious and welcoming pub-club atmosphere. There's usually no cover charge and drinks are fairly priced.

✉ **54 Jaffe Road, Wan Chai, Hong Kong Island** ☎ **2861 1621** ⏰ **Daily 9PM–2AM** 🚇 **Wan Chai**

Event Information

Details of current listings and other information regarding clubs, bars, live music venues and most other cultural and entertainment events can be found in the Hong Kong Tourist Association's free *Official Dining and Entertainment Guide*, available from tourist offices (➤ 118) and in the free weekly *H K Magazine*, widely available in shops, bars, hotels and restaurants. Also try newspapers such as the daily *South China Morning Post*, and the large bulletin boards outside City Hall by the Star Ferry terminal also hold posters and listings of forthcoming events.

Nightlife Locations

Entertainment venues are scattered across the city, but the main concentration of bars, clubs and restaurants in Central are gathered in the tightknit Lan Kwai Fong area (➤ 53). Wan Chai's Lockhart Street and the surrounding area, another nightlife enclave, has traditionally had a rather down-at-heel atmosphere, but high rents elsewhere have seen the opening of new and more enticing venues. The Tsim Sha Tsui district is also good for nightlife, appealing to younger visitors, though here, too, new venues have turned the little area around Knutsford Terrace (a block north of Kimberley Road) into Kowloon's newly trendy equivalent of Lan Kwai Fong.

Pubs & Bars

Bars and Hostess Clubs

It is well worth noting that in Hong Kong the distinction between clubs, pubs, bars and restaurants is often blurred. Many bars serve full meals and many have live music some nights or a small dance floor for late-night dancing. When it comes to the city's other well-known nightspots, the so-called hostess bars, 'girlie' bars or topless bars, there is just one word – don't. Although pushed by the Tourist Association as a typical Hong Kong experience, most of these places are indescribably sleazy, sell drinks at exorbitant prices, and often conjure up numerous ways of fleecing gullible tourists.

If curiosity gets the better of you, the two most famous such bars are Bottoms Up (⊠ 14 Hankow Road, Tsim Sha Tsui, Kowloon), notable principally because part of the James Bond film *The Man with the Golden Gun* was shot here, and the extraordinary and super-smart Club BBoss (*sic*), supposedly the largest club of its type in the world (⊠ New Mandarin Plaza, 14 Science Museum Road, Tsim Sha Tsui).

Bahama Mamas

One of the first bars in the newly trendy entertainment enclave around Knutsford Terrace. Fine for a drink, with outdoor terrace and a Caribbean-inspired beach theme, but at its best as a club and disco.

⊠ 4–5 Knutsford Terrace, off Kimberley Road, Tsim Sha Tsui, Kowloon ☎ 2368 2121
🕐 Mon–Thu 6PM–3AM; Fri–Sat 6PM–5AM; Sun 6PM–2AM
🚇 Tsim Sha Tsui ❓ Cover charge on club nights

The Bar

The Bar in the Peninsula, one of the city's top hotels, is among the classiest hotel venues: it comes with pianist, cocktails, fluted columns, views and fine beamed ceilings.

⊠ Peninsula Hotel, Salisbury Road, Tsim Sha Tsui, Kowloon ☎ 2366 6215, ext 3163
🕐 Daily noon–1AM 🚇 Tsim Sha Tsui

Bull and Bear

One of the city's favourite British style bars, this pub-restaurant has a mock-Tudor beamed interior and serves comforting pub-style English food. Busy with office-workers during 'happy hour' and particularly rowdy at weekends.

⊠ Hutchinson House, 10 Harcourt Road, Central, Hong Kong Island ☎ 2525 7436
🕐 Mon–Sat 8AM–2AM, Sun 12–12. Happy hour daily 5–8
🚇 Admiralty

California

A long-established and rather smart designer bar and American-style restaurant, but none the worse for that. Bright and fashionable, in an excellent location.

⊠ California Tower, 24–6 Lan Kwai Fong Lane, Central, Hong Kong Island ☎ 2521 1345
🕐 Mon–Thu noon–1AM, Fri–Sat noon–4AM, Sun 5PM–1AM
🚇 Central

Club 64

Perhaps the nicest and most informal of the bars in Central's main Lan Kwai Fong nightlife district. Not as smart as many in the vicinity, but that is part of its appeal.

⊠ 12–14 Wing Wah Lane, Central, Hong Kong Island ☎ 2523 2801 🕐 Daily 11AM–2AM. Happy hour 11AM–8PM 🚇 Central

La Dolce Vita

An ultra-chic Italian-style place where people come to see and be seen, nibble snacks and tuck into pasta and other Italian dishes.

⊠ Cosmos Building, 9–11 Lan Kwai Fong, Central, Hong Kong Island ☎ 2810 9333 🕐 Sun–Thu 9AM–2AM, Fri–Sat 9AM–4AM. Happy hour daily 4–8
🚇 Central

Schnurrbart

Bavarian-style beer cellar with German beer, 25 types of schnapps and a juke box with Western pop hits.

⊠ Winner Building, 29 D'Aguilar Street, Central, Hong Kong Island ☎ 2523 4700 or 2366 2986 🕐 Mon–Thu 12–12:30AM, Fri–Sat 12–1:30AM, Sun 6PM–12:30AM 🚇 Central

Shenman's Bar and Grill

A very pleasant and polished modern bar in the Lan Kwai Fong district.

⊠ California Building, 34–6 D'Aguilar Street, Central, Hong Kong Island ☎ 2801 4946
🕐 Mon–Sat 12–12 🚇 Central

Clubs & Discos

BB'S
A beacon amidst the sleaze of many Wan Chai bars and clubs. Cool and modern, it also offers late-night jazz and dancing upstairs.

✉ **114–120 Lockhart Road, Wan Chai, Hong Kong Island** ☎ 2529 7702 🕐 Daily 9:30AM–3AM. Happy hour 4–9 🚇 Wan Chai

Catwalk
A glittering complex with resident salsa band, other live bands, disco, video screens, 11 private singing rooms and a karaoke lounge.
New World Hotel, 22 Salisbury Road, Tsim Sha Tsui, Kowloon ☎ 2369 4111 ext 6380 🕐 Sun–Thu 9PM–2:30AM; Fri–Sat 9PM–3:30AM 🚇 Tsim Sha Tsui

Club City
The largest nightlife complex in Hong Kong – divided into 12 different 'themed' areas with extraordinary décor through-out. Two dance floors, three stages, karaoke area and a gargantuan bar.

✉ **Chinachem Golden Plaza, 77 Mody Road, Tsim Sha Tsui, Kowloon** ☎ 2311 1111 🕐 Daily 8PM–4AM 🚇 Tsim Sha Tsui

Club Shanghai
This club with dance floor and bar-lounge offers some dramatic harbour views. Resident band and other live music. Dinner and bar until 9:30PM, then music and dancing.

✉ **Regent Hotel, 18 Salisbury Road, Tsim Sha Tsui, Kowloon** ☎ 2721 1211 ext 2242 🕐 Dinner: daily 6–9:30PM. Live music: Sun–Thu 6PM–2AM; Fri–Sat 6PM–3AM 🚇 Tsim Sha Tsui

Flying Pig
One of the most infamous and rowdy of Wan Chai's clubs, appealing to a young crowd.

✉ **81–85 Lockhart Road, Wan Chai, Hong Kong Island** ☎ 2865 3730 🕐 Mon–Thu 11:30AM–3AM; Fri–Sat 11:30AM–4AM; Sun 3:30PM–2AM 🚇 Wan Chai

JJ's
A smart, popular complex with impressive disco, bars, live music, games room, plus diner food. Frequented mostly by Hong Kong's business people, but also a reliable standby for visitors.

✉ **Grand Hyatt Hotel, 1 Harbour Road, Wan Chai, Hong Kong Island** ☎ 2588 1234 🕐 Mon–Thu 5:30PM–2AM; Fri 5:30PM–3AM, Sat 6PM–4AM. Closed Sun. Happy hour Mon–Fri 5:30–8:30 🚇 Wan Chai ❓ Dress should be reasonably smart. Cover charge after 8:30

Joe Bananas
Very popular American-style bar, the atmosphere is lively and unpretentious at most times of the day. Operates as a bar early on; dancing comes later.

✉ **Shiu Lam Building, 23 Luard Road, Wan Chai, Hong Kong Island** ☎ 2529 1811 🕐 Mon–Thu 11AM–5AM; Fri–Sat 11AM–6AM. 🚇 Wan Chai ❓ Dress code for men: no shorts, sports shoes; shirts must have a collar; no T-shirts

Neptunes
Loud, crowded and popular club; friendly, despite its down-at-heel look.

✉ **62 Lockhart Road, Wan Chai, Hong Kong Island** ☎ 2527 5276 🕐 Daily 4PM–5AM 🚇 Wan Chai

Cover Charges
Many of Hong Kong's dance clubs are in the Wan Chai district on and around Lockhart, Jaffe and Lugard roads. Most are smart affairs where the latest fashions rule – the crazier the better – though the city's clubs tend to be less intimidatingly trendy than those in London or New York. However, prices are often high by western standards, and most clubs have a cover charge, though this usually includes the price of one or two drinks. Reckon on anything up to HK$250 for the most expensive places. Many clubs are free from Monday to Thursday and only levy a cover charge on Friday and Saturday. Others may admit women free, or admit men and women free until a certain time.

What's On When

Moon Cake Festival

Hong Kong's autumn Moon Cake Festival, held on the 15th day of the year's eighth moon, is one of the most colourful celebrations of the year. Similar to western harvest festivals, part of the celebrations commemorate a 14th-century uprising against the Mongols. During the revolt the rebels wrote the call to arms on pieces of paper that were embedded in cakes and smuggled to their companions. Today people still eat special 'Moon cakes' (*yuek beng*) made from sesame and ground lotus. People also buy brightly coloured lanterns which are taken at night to parks and high vantage points such as the Peak. Families eat their cakes as they watch the rising of the autumn moon.

January

Hong Kong Arts Festival late-Jan to Feb (➤ 112) and Hong Kong Fringe Festival (➤ 112).
Hong Kong Marathon (late Jan).

February

Hong Kong Arts Festival–Fringe Festival.
Chinese New Year (usually early Feb): family celebrations, New Year Parade and harbour fireworks display.
Spring Lantern (Yuen Siu) Festival and Carnival: last day of the Chinese New Year.

March

Hong Kong Rugby Sevens (early Mar).
Hong Kong Open Golf Championship (early Mar).
Hong Kong Food Festival.
Hong Kong International Film Festival (➤ 112, side panel).

April

Ching Ming Festival: Chinese families visit the burial places of relatives.
Tin Hau Festival: a celebration of the birth of the sea goddess; fishermen decorate boats and special celebrations are held in Tin Hau temples.

May

Birthday of Lord Buddha: decoration of temple statues, especially on Lantau.
Christie's Hong Kong Spring Auctions.
Dragon Boat (Tuen Ng) Festival: decorated boats and races.
Tai Chiu (Bun) Festival on Cheung Chau Island: a popular three-day festival culminating in a grand procession.
Tam Hung Festival: celebrates the second patron god of the fishing community.

June

Hong Kong Dragon Boat Festival: colourful festival of decorated boats and races. End of the horse-racing season.

July

Lu Pan Festival: celebrations to honour the god of those connected with building trades.

August

Maidens' or Seven Sisters' Festival (mid-Aug): offerings are made by lovers and young girls who pray for husbands.
Hungry Ghosts (Yue Lan) Festival: food is set out to placate troubled spirits.

September

Mid-Autumn Carnival and Lantern Festival (or Moon Cake Festival): a harvest-type festival which celebrates a 14th-century uprising against the Mongols.
Birthday of Confucius, celebrated Chinese philosopher.

October

Festival of Asian Arts (➤ 112).
Cheung Yeung festival (public holiday): families visit the graves of relatives and high places to commemorate a Han Dynasty (206 BC–AD 220) legend in which such a journey saved an old man and his family from disaster.

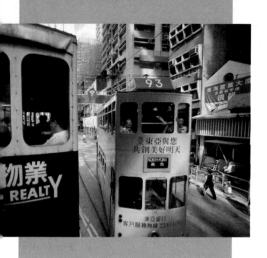

Practical Matters

Above: *getting around by tram*
Below: *Chek Lap Kok Airport*

TIME DIFFERENCES

GMT
12 noon

Hong Kong
→ 8PM

Germany
→ 1PM

USA (NY)
← 7AM

Netherlands
→ 1PM

Spain
→ 1PM

BEFORE YOU GO

WHAT YOU NEED

● Required
○ Suggested
▲ Not required

	UK	Germany	USA	Netherlands	Spain
Passport/National Identity Card	●	●	●	●	●
Visa	▲	▲	▲	▲	▲
Onward or Return Ticket	●	●	●	●	●
Health Inoculations	▲	▲	●	▲	▲
Health Documentation (reciprocal agreement document ➤ 123, Health)	▲	▲	▲	▲	▲
Travel Insurance	●	○	●	○	○
Driving Licence (National or International)	●	●	●	●	●
Car Insurance Certificate (hire cars)	●	●	●	●	●
Car Registration Document (hire cars)	●	●	●	●	●

WHEN TO GO

Hong Kong

▬▬▬ High season

▭▭▭ Low season

18°C	17°C	19°C	24°C	28°C	29°C	31°C	31°C	29°C	27°C	23°C	20°C
JAN	FEB	MAR	APR	MAY	JUN	JUL	AUG	SEP	OCT	NOV	DEC

☁ Cloud ☀ Sun ⛅ Sunshine and showers

TOURIST OFFICES

In the UK
Hong Kong Tourist
Association (HKTA)
6 Grafton Street
London W1X 3LB
☎ (0171) 533 7100
Fax: (0171) 533 711

In the USA
Hong Kong Tourist
Association (HKTA)
5th Floor, 590 5th Avenue
Suite 590
New York, NY 10036-4706
☎ (212) 869/5008;
Fax: (212) 730/2605

Hong Kong Tourist
Association (HKTA)
10940 Wilshire Boulevard
Suite 122,
Los Angeles
CA 90024-3915
☎ (310) 208/4582

POLICE 999

FIRE 999

AMBULANCE 999

OTHER CRISIS LINES – SEE LOCAL PHONE BOOK

country code 00852

ARRIVING

Chek Lap Kok International Airport opened in July 1998 west of the business district, offering a wide range of facilities. Information and gift centres are located in the Buffer Hall and on Level 5 of the Arrivals Hall (daily, 6am–12am). For enquiries ☎ 852 2807 6177 (multilingual).

Hong Kong Airport
Kilometres to city centre

Journey Times

25 kilometres

 23 minutes

 60 minutes

 45 minutes

MONEY

The monetary unit of Hong Kong is the Hong Kong dollar (HK$ or $) and cents, written as c (100 cents = 1 HK$). Notes vary slightly in design but come in denominations of $10, $20, $50, $100, $500 and $1,000. Silver coins come as $1, $2 and $5, bronze coins as 10c, 20c and 50c. (The $10 note is to be replaced by a $10 silver coin.) Major credit cards are widely accepted but an (illegal) 3–5 per cent commission may be added for credit card payments. Cash advances are available with major cards with a PIN number from automatic teller machines (ATM). Exchange facilities at banks and elsewhere are widely available to change currency and travellers' cheques.

TIME

 Hong Kong is in a single time zone 8 hours ahead of GMT (GMT+8).

CUSTOMS

 YES

Hong Kong is a duty-free port, but duty is still charged on certain items. The duty-free allowances for visitors to the city are:

Alcohol: 1L
Cigarettes: 200 *or*
Cigars: 50 *or*
Tobacco: 250g
Perfume: 60ml
Toilet water: 250ml

There are no restrictions on the import or export of Hong Kong currency.

 NO

Drugs, weapons, firearms, fireworks, wildlife and associated products. Permits are required to import or export ivory. Penalties for drug offences are extremely severe, including up to life imprisonment.

EMBASSIES AND CONSULATES

UK	Germany	USA	Netherlands	Spain
2824 6111	2529 8855	2523 9011	2522 5127	2525 3041

WHEN YOU ARE THERE

TOURIST OFFICES

- **Hong Kong Tourist Association (HKTA)**
 Shop 8, Basement Level
 Jardine House
 1 Connaught Place
 Central
 Hong Kong Island
 ☎ 2807 6177

- **Hong Kong Tourist Association (HKTA)**
 Star Ferry Concourse
 Tsim Sha Tsui
 Kowloon
 ☎ 2807 6177

- **Hong Kong Tourist Association (HKTA)**
 Hong Kong International Airport
 Lantau
 ☎ 852 2807 6177 (multi-lingual);
 852 2807 6133 (Mandarin);
 852 2807 6188 (Japanese)

NATIONAL HOLIDAYS

J	F	M	A	M	J	J	A	S	O	N	D
2	(1)	1(3)	(1)		1		1	1	1		2

1 Jan	New Year's Day
Jan/Feb	Chinese New Year (3 days)
Mar/Apr	Good Friday and Easter Monday
Apr	Ching Ming (1 day early Apr)
Jun	Dragon Boat Festival
Aug	Liberation Day (last Mon and Sat before last Mon in August)
Sep	Mid-autumn Festival
Oct	Cheung Yeung Festival
Dec 25	Christmas Day
Dec 26	Boxing Day

Hong Kong's public holidays may change as China replaces former colonial holidays with new national holidays. Dates of the Chinese lunar festivals vary from year to year.

OPENING HOURS

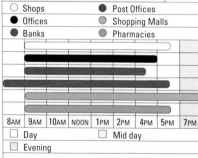

○ Shops	● Post Offices
● Offices	○ Shopping Malls
● Banks	○ Pharmacies

| 8AM | 9AM | 10AM | NOON | 1PM | 2PM | 4PM | 5PM | 7PM |

☐ Day	☐ Mid day
☐ Evening	

Opening hours for museums vary. Shops, shopping malls and pharmacies sometimes open later than shown. Banks also open on Saturday from 9–12:30, and offices 9–1 and post offices from 8–2.

DRIVE ON THE
LEFT

TOILETS
POOR

PUBLIC TRANSPORT

 Mass Transit Railway (MTR) The most useful mode of transport after taxis, linking all main Hong Kong Island districts. It runs under the harbour between Hong Kong Island and Tsim Sha Tsui in Kowloon. Fast, fully-automated, efficient, safe, clean and air-conditioned. Tickets are available from machines at stations. Exact money in notes or coins is required: change machines are available on most stations. Fares vary from around HK$5 to HK$15. No returns are available and tickets are valid for 90 minutes from time of purchase. Multi-journey passes cost from $25 and can be used until credit on the ticket is exhausted.

 Buses Double decker buses run from 6AM to midnight. Fares are posted at the entrance to buses and are paid on board (exact change is required) and vary according to destination and whether the bus is air-conditioned. Drivers rarely speak English. Small yellow passenger minibuses with a red stripe also run, but you won't often need this service. Pay as you get off.

 Trams Trams run east to west (and back) across the north side of Hong Kong Island (6AM–1AM). Enter trams at the rear. There is a flat fare and exact change is required. Pay on exiting by placing money in the box provided. The Peak Tram is a funicular which operates independently of the tram system.

 Ferries ➤ 24 for details of how to use the Star Ferry system between Hong Kong Island and Kowloon. The ferry terminal for boats to the outlying islands and elsewhere is located to the west of the Star Ferry terminal on Hong Kong Island. Buy tickets from booths at the individual ferry piers.

DRIVING

 Speed limit through tunnels and on highways: **70mph**

 Speed limit on other roads: **30–50mph**

 It is compulsory for drivers and front-seat passengers to wear seat belts at all times.

 Drunken driving and all other traffic offences are dealt with severely. Police are strict and ever ready to issue traffic tickets.

Petrol is extremely expensive – petrol tax is 100 per cent – in a deliberate attempt to discourage driving and keep cars off Hong Kong's overcrowded streets.

 In case of breakdown while driving a rental car, you should contact the car rental company, which should arrange to send a road service to your location to repair the vehicle.

CAR RENTAL

 It is simply not worth renting a car in Hong Kong unless you make extensive visits to the mainland. Cars save no time in the city (public transport is quicker) and parking is all but impossible. Car rental companies can be found in the Yellow Pages.

TAXIS

 Hong Kong taxis are red and represent extremely good value: prices are so cheap – just $14 for the first 2km – that you can use them to travel long distances in the city. Most drivers cannot speak English, but most taxis have translation cards displaying the names of 50 major destinations. Leaving hotels, it is a good idea to tell Chinese hotel staff where you wish to go and ask them to translate. Crossing by tunnel between Hong Kong Island and Kowloon involves a surcharge. Taxis for hire display a 'For Hire' sign on the windscreen: at night a 'Taxi' sign is lit on the roof. Taxis cannot stop at bus stops or where a yellow line is painted on the road.

CENTIMETRES

INCHES

PERSONAL SAFETY

- Always carry identification
- Guard against pickpockets
- Carry money, wallets and purses securely
- Keep travellers' cheques separate from their invoice
- Leave valuables and documents in hotel safes
- Public transport is invariably safe both night and day
- Pay careful attention to summer typhoon warnings
- Use only registered taxis from designated ranks
- Most of the city is safe, but treat lonely and unlit areas with caution

Police assistance:

☎ **999**

from any call box

ELECTRICITY

The power supply is 200/220 volts AC, 50 Hz.

 Most wall outlets take three square pins, though some older ones take three round pins. Appliances from the US will require a plug adaptor or voltage adaptor unless fitted with a 110/220V switch.

TELEPHONES

Local calls within Hong Kong are free for subscribers but cost $1 per call from public phone boxes, all of which carry instructions in English. Some public phones only accept $2 pieces and give no change: press the FC (Follow-on Call) button before hanging up to make a second call. Phone cards, widely available in $50, $100 or $250 denominations, are useful when making IDD (International Direct Dialling) calls. Some phone boxes accept coins only, others cards only; others ('Duet' phones) accept both. Credit card phones are also increasingly common. Dial 013 for information regarding international calls.

International Dialling Codes

From Hong Kong dial 001 then to:

UK:	44
Germany:	49
USA & Canada:	1
Netherlands:	31
Spain:	34

POST

The main post office on Hong Kong Island is at 2 Connaught Place, Central (☎ 2921 2222). Letters sent *poste restante* are delivered here (take a passport when collecting mail) unless addressed to Kowloon's main office at 10 Middle Road, just off the lower end of Nathan Road. Overseas delivery can be speeded up by using 'Speedpost'. Offices are open Mon–Fri 8–6, Sat 8–2.

TIPS/GRATUITIES

Yes ✓ No ✗

Restaurants	✓	10 per cent
Bar service	✓	Discretionary
Taxis	✓	10 per cent
Tour guides	✓	Discretionary
Hairdressers/Beauty Salons	✓	10 per cent
Chambermaids	✓	Discretionary
Hotel Porters	✓	$1–2 a bag
Cloakroom attendants	✓	Discretionary
Toilets	✗	

What to photograph: Signs banning photography are posted at the airport, customs and immigration and ferry terminals. Views from the Peak, markets, harbour, cityscape and night scenes offer photographic opportunities.
When to photograph: On bright days allow for the intensity of the midday light: it is best to photograph early in the morning or late in the afternoon. Allow for reflected light when taking pictures near water.
Where to buy film: Hong Kong is packed with shops selling cameras, film and other photographic equipment.

HEALTH

Insurance
Basic treatment in casualty wards is free, but all other medical care, consultations, dentistry and hospital treatment are charged. It is strongly recommended that all travellers take out a comprehensive travel insurance policy.

Dental Services
Dental treatment is expensive in Hong Kong and if possible should be deferred until you return home. In an emergency call the Hong Kong Dental Association (☎ 2528 5327) for a list of accredited dentists or consult the *Yellow Pages* under 'Dental Practitioners'.

Doctors
Doctors and dentists in Hong Kong are both often known as 'doctors'. Ask your hotel for an accredited doctor, visit a local public hospital or clinic, or consult the *Yellow Pages* under 'Physicians and Surgeons' for details of English-speaking doctors. Keep receipts of charges for consultations and treatment for future insurance claims.

Medicines
Prescription and non-prescription drugs are available from chemists or pharmacies. Watson's and Manning's are the largest Hong Kong-wide chains. Opening hours are usually 9–6. Bring copies of prescriptions for medicines you are likely to require. Keep receipts for insurance purposes.

Safe Water
It is safe to drink tap water everywhere in urban Hong Kong. Bottled mineral water is widely available.

CONCESSIONS

Students/Youths A handful of discounts are available to holders of an International Student Identity Card (ISIC). Consult travel agents for details of any concessions on fares for students or travellers under 26.

Senior Citizens A few tourist attractions offer discounts to senior citizens and you may have to produce proof of age. When booking hotels or entering restaurants enquire at the outset whether concessions are offered.

CLOTHING SIZES

Hong Kong	UK	Rest of Europe	USA	
46	36	46	36	
48	38	48	38	
50	40	50	40	
52	42	52	42	Suits
54	44	54	44	
56	46	56	46	
41	7	41	8	
42	7.5	42	8.5	
43	8.5	43	9.5	
44	9.5	44	10.5	Shoes
45	10.5	45	11.5	
46	11	46	12	
37	14.5	37	14.5	
38	15	38	15	
39/40	15.5	39/40	15.5	
41	16	41	16	Shirts
42	16.5	42	16.5	
43	17	43	17	
36	8	34	6	
38	10	36	8	
40	12	38	10	
42	14	40	12	Dresses
44	16	42	14	
46	18	44	16	
38	4.5	38	6	
38	5	38	6.5	
39	5.5	39	7	
39	6	39	7.5	Shoes
40	6.5	40	8	
41	7	41	8.5	

WHEN DEPARTING

- Departure tax from the city is HK$50.
- Make sure to check your departure details carefully and check in well in advance.

LANGUAGE

Hong Kong has two official languages: English and Cantonese, a dialect of Chinese. English is widely spoken in the business community and in tourist areas, but many people living in Hong Kong may have come from the Chinese mainland, and may not necessarily understand English. It is a good idea to ask the hotel receptionist to write down your destination in Chinese to avoid confusion with taxi drivers or bus drivers. The Hong Kong Tourist Association (HKTA) has introduced a system of colour-coded badges for people working in tourism-related establishments: a purple badge or strip indicates a German speaker; blue indicates proficiency in French.

Even so, a few words of Cantonese go a long way in establishing rapport with local people, and may prove especially useful on excursions outside the city. Cantonese originates in the southern Chinese province of Canton (Guangdong). It is extremely difficult to the foreign ear, as it uses a number of different musical intonations to differentiate syllables. Therefore, one part of a word could have many different variations in sound which would then change its meaning. Mandarin, the other major Chinese dialect, is only understood to a certain degree.

Written Chinese is also a very complex calligraphic art , with a single character requiring up to 30 pen or brush strokes to create. Chinese is written from left to right or sometimes from right to left.

 Common words and phrases

can you speak English?	*neih wuih mwuih gong ying mahn?*
good morning	*jóu sahn*
hello (on the telephone)	*wai!*
thank you (for a favour/ service)	*mgoi*
thank you (for a gift)	*do jeh*
please	*mgoi*
excuse me	*mgoi*
yes	*haih/hou*
no	*mhaih/mhou*
where?	*bin douh?*
how many/much?	*géi dõ?*
airport	*fèi gèi chèung*
bus	*bã si*
tram	*dihn chè*
tea	*chàh*
beer	*bè jáu*
taxi	*dik sí*
Hong Kong	*Hèung Góng*
Kowloon	*Gáu Lùhng*
The Peak	*Sàn Déng*
The Peak Tram	*Laahm Chè*
dollar	*mãn*
pound sterling	*yìng bóng*

Numerals

0	*leng*
1	*yãt*
2	*yih*
3	*sàam*
4	*sei*
5	*ngh*
6	*luhk*
7	*chát*
8	*baat*
9	*gáu*
10	*sahp*
11	*sahp yãt*
20	*yih sahp*
21	*yih sahp yãt*
30	*sàam sahp*
31	*sàam sahp yãt*
40	*sei sahp*
50	*ngh sahp*
60	*luhk sahp*
70	*chát sahp*
80	*baat sahp*
90	*gáu sahp*
99	*gáu sahp gáu*
100	*yãt baak*
1,000	*yãt chihn*
three o'clock	*sàam dím jung*

INDEX

Acknowledgements
The Automobile Association wishes to thank the following photographers and
libraries for their assistance in the preparation of this book:

MARY EVANS PICTURE LIBRARY 10b, 11b; HONG KONG TOURIST
ASSOCIATION F/cover a (Buddha), b (Hong Kong skyline), d (dragon dance), B/cover
(mid-autumn festival), 2, 5a, 5b, 6b, 8b, 8/9, 9b, 13, 15b, 24/5, 32b, 34/5, 36b, 38b,
39, 42b, 43c, 46b, 47, 54b, 55a, 55b, 56a, 57a, 72b, 73b, 77b, 80, 84, 85, 86b, 89b,
90b; HONG KONG SCIENCE MUSEUM 21b; REX FEATURES 14b, 14c, 117b;
SOUTH CHINA MORNING POST 122 (TONY AW), SPECTRUM COLOUR LIBRARY
22b, 41b, 48b, 51, 53b; TRAVEL INK (D ALLAN) 40b; HONG KONG UNIVERSITY
MUSEUM AND ART GALLERY 45b; WORLD PICTURES 59b, 75b; MRI BANKERS'
GUIDE TO FOREIGN CURRENCY 119.

The remaining photographs are held in the Association's own photo library
(AA PHOTO LIBRARY) and were taken by Alex Kouprianoff.

Author's Acknowledgements
The author would like to thank Virgin Atlantic Airlines, the Hong Kong Tourist Association and
Michael Sheridan and Sophy Fisher.

Copy editor: Lyn Bresler **Page layout**: Stuart Perry

Dear Essential Traveller

Your comments, opinions and recommendations are very important to us. So please help us to improve our travel guides by taking a few minutes to complete this simple questionnaire.

You do not need a stamp (unless posted outside the UK). If you do not want to cut this page from your guide, then photocopy it or write your answers on a plain sheet of paper.

Send to: **The Editor, AA World Travel Guides, FREEPOST SCE 4598, Basingstoke RG21 4GY.**

Your recommendations…

We always encourage readers' recommendations for restaurants, nightlife or shopping – if your recommendation is used in the next edition of the guide, we will send you a *FREE* AA *Essential* **Guide** of your choice. Please state below the establishment name, location and your reasons for recommending it.

Please send me **AA** *Essential* _____
(*see list of titles inside the front cover*)

About this guide…

Which title did you buy?
AA *Essential* _____
Where did you buy it? _____
When? m m / y y

Why did you choose an AA *Essential* Guide? _____

Did this guide meet your expectations?
Exceeded ☐ Met all ☐ Met most ☐ Fell below ☐
Please give your reasons _____

continued on next page…

Were there any aspects of this guide that you particularly liked? _____

Is there anything we could have done better? _____

About you…

Name (*Mr/Mrs/Ms*) _____

 Address _____

_____ Postcode _____

 Daytime tel nos _____

Which age group are you in?

 Under 25 ☐ 25–34 ☐ 35–44 ☐ 45–54 ☐ 55–64 ☐ 65+ ☐

How many trips do you make a year?

 Less than one ☐ One ☐ Two ☐ Three or more ☐

Are you an AA member? Yes ☐ No ☐

About your trip…

When did you book? m m / y y When did you travel? m m / y y

How long did you stay? _____

Was it for business or leisure? _____

Did you buy any other travel guides for your trip?

 If yes, which ones? _____

Thank you for taking the time to complete this questionnaire. Please send
it to us as soon as possible, and remember, you do not need a stamp
(*unless posted outside the UK*).

Happy Holidays!